FIND MOMO

MY DOG IS HIDING IN THIS BOOK.
CAN YOU FIND HIM?

A photography book by Andrew Knapp

QUIRK BOOKS
PHILADELPHIA

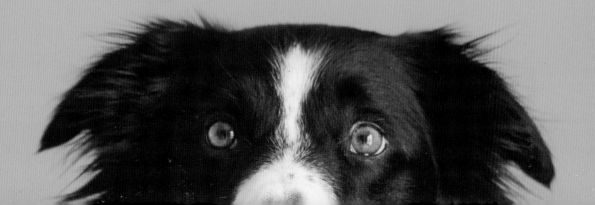

Library of Congress Cataloging in
Publication Number: 2013911676
ISBN: 978-1-59474-678-9

Printed in China
Typeset in Sentinel and Trend Sans

Designed by Andie Reid
Photography by Andrew Knapp
Additional photography by Zach Rose
(back cover flap and pages 141, 142, and 148)
and by Harriet Carlson (page 128)
Editorial assistance by Jane Morley
Production management by John J. McGurk

Quirk Books
215 Church Street
Philadelphia, PA 19106
quirkbooks.com

10 9 8 7 6 5 4 3 2 1

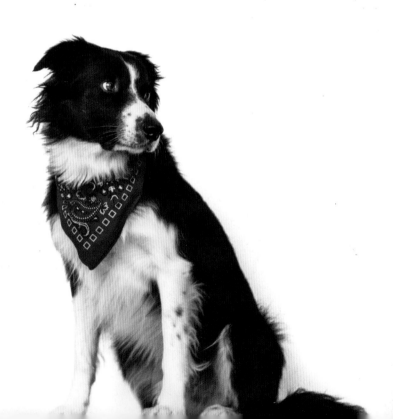

To Kayla, Noah, Kennedy,
Ethan, Vanessa...and to you.

EXPLORE, CREATE, STAY CURIOUS.

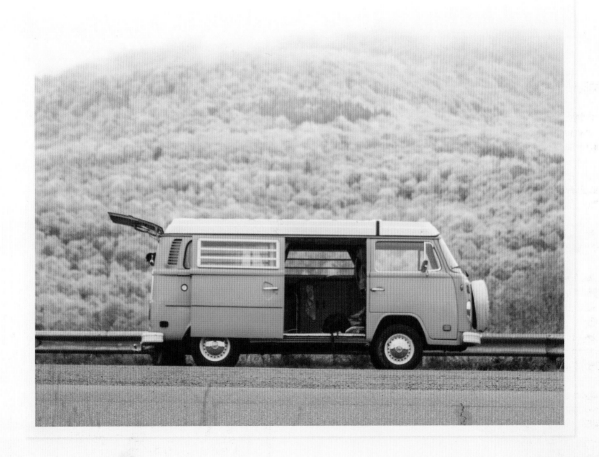

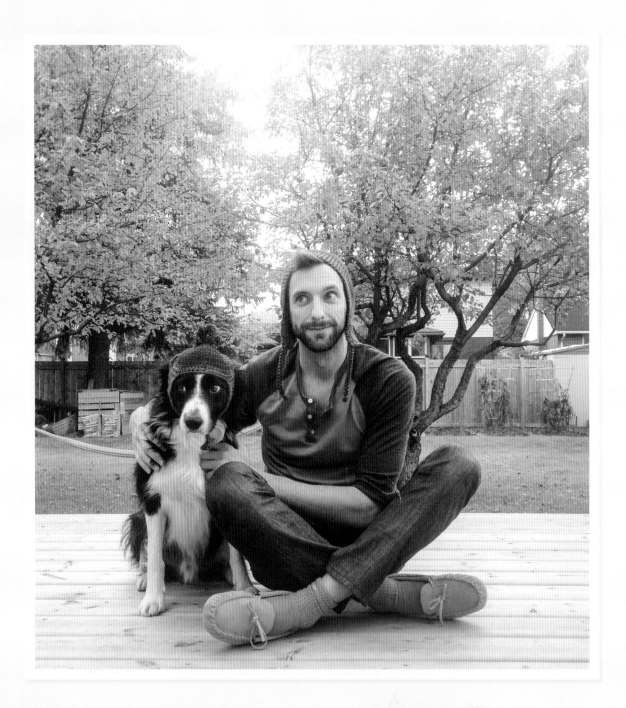

HI THERE!

I'm Andrew, and this is my buddy Momo.

He likes to hide. In fact, Momo's hiding in every picture in this book.

Think you can find him?

OKAY MOMO, GO HIDE!

HINT: Momo's in there somewhere . . . keep looking! (If you ever have trouble finding Momo, just check the answer key at the back of this book.)

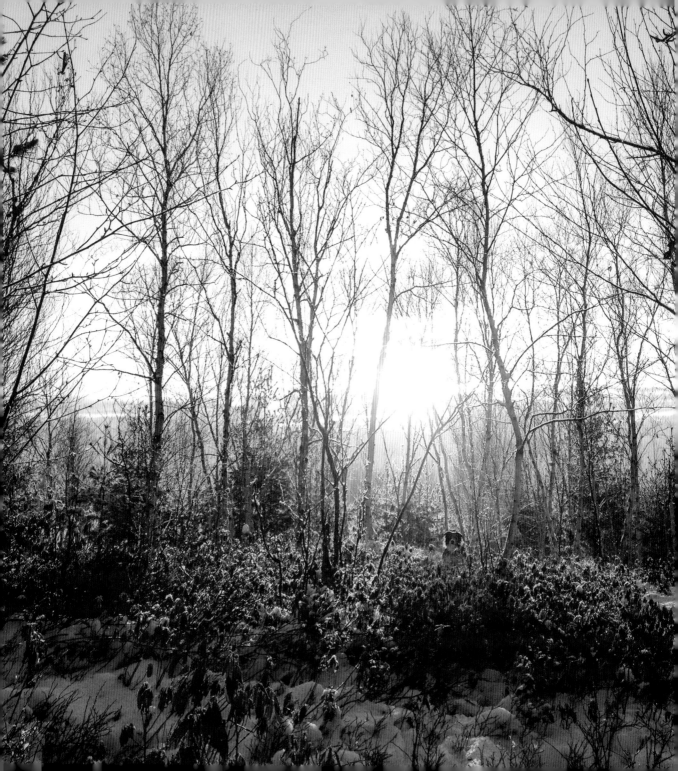

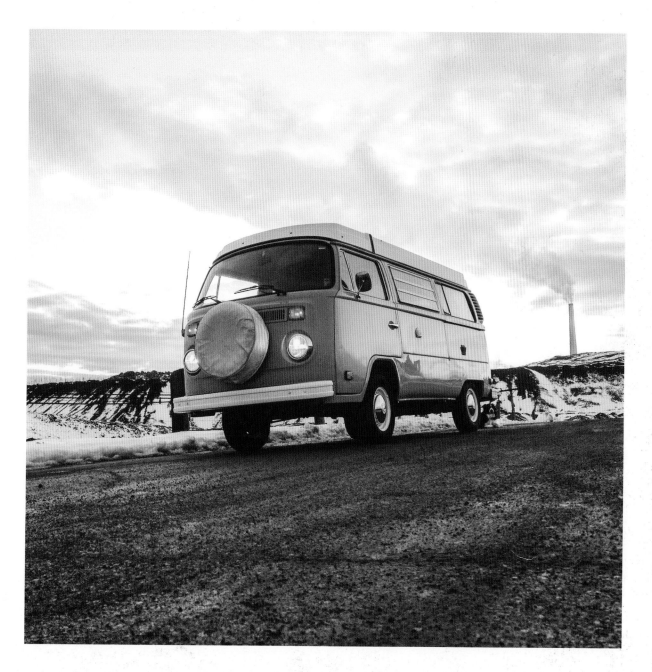

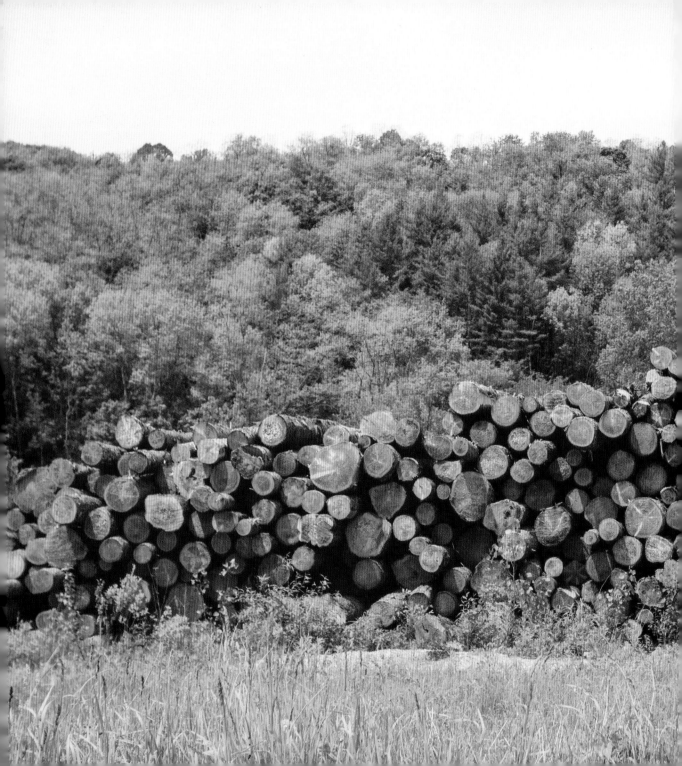

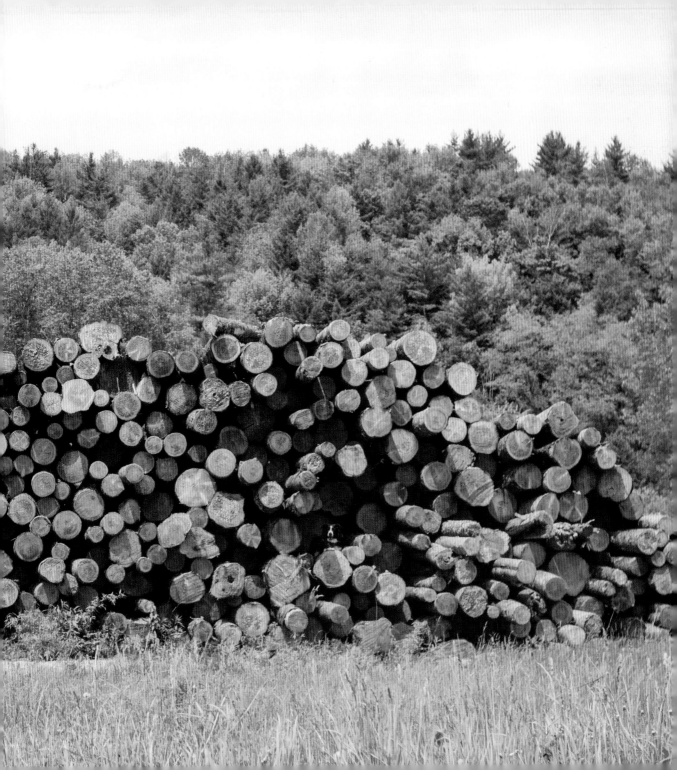

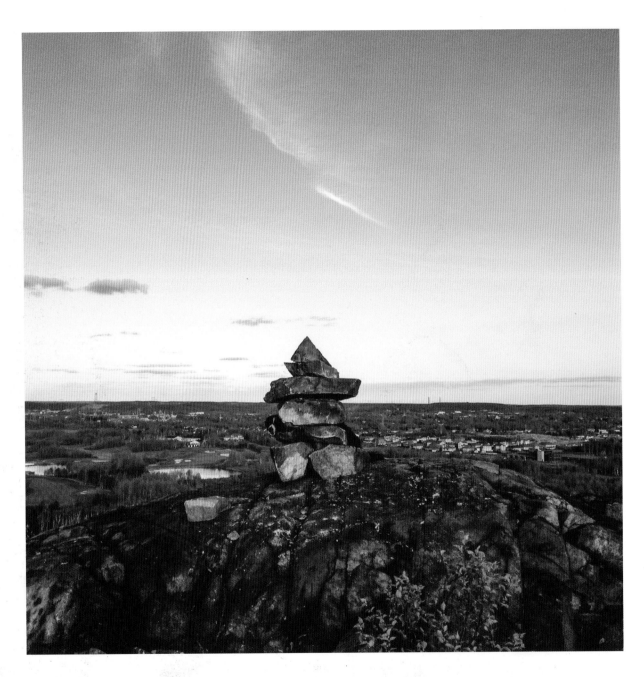

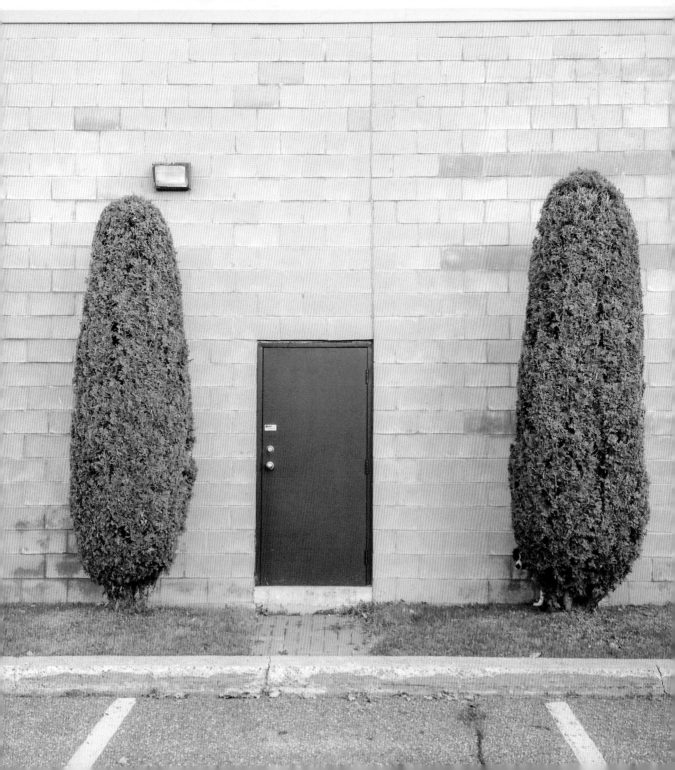

MOMO'S VITAL STATISTICS

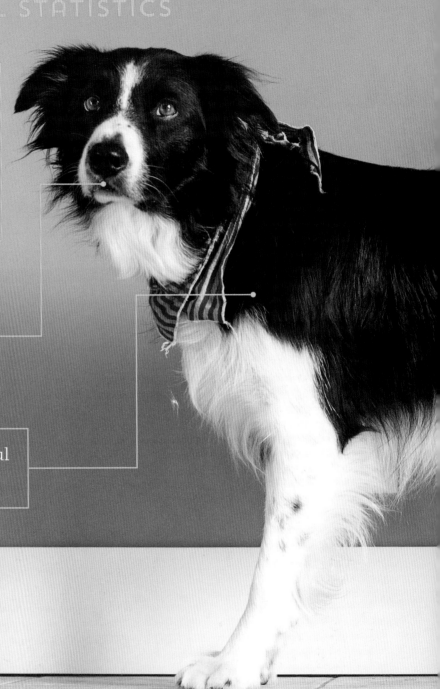

Born: June 19, 2008,
in Orillia, Ontario,
Canada

Parents: Cedar (mom)
and Jackson (dad)

Favorite foods:
Anything stinky
and/or wet

Main squeeze: A beautiful
rottweiler named Nova

Weight: 45 pounds

Favorite toys: Balls, frisbees, sticks, rope toys, rawhide bones—and snowballs most of all

Height: 2 feet

Favorite place to sleep: At Andrew's feet

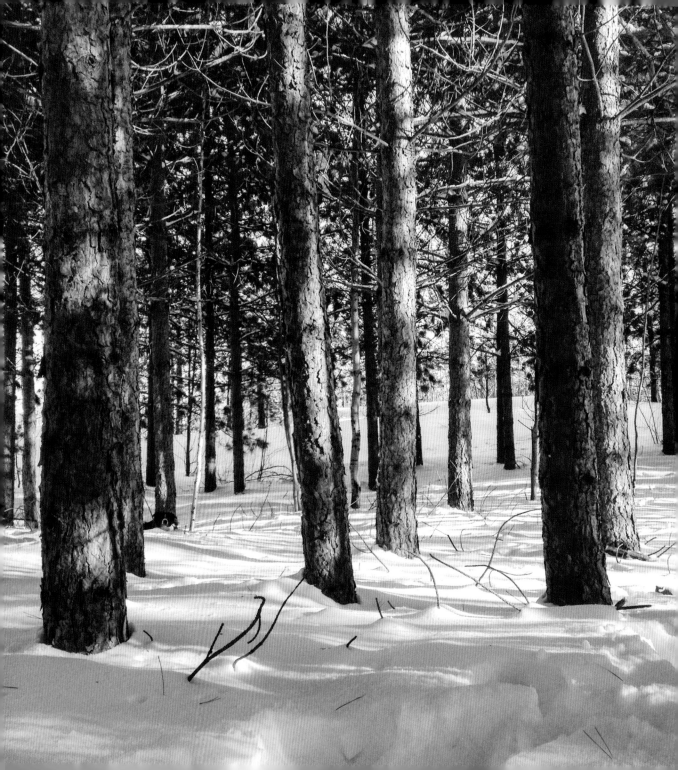

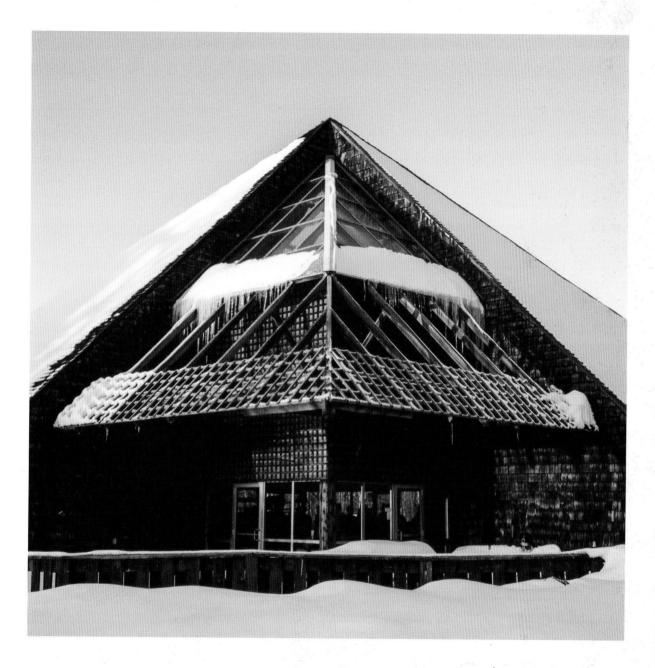

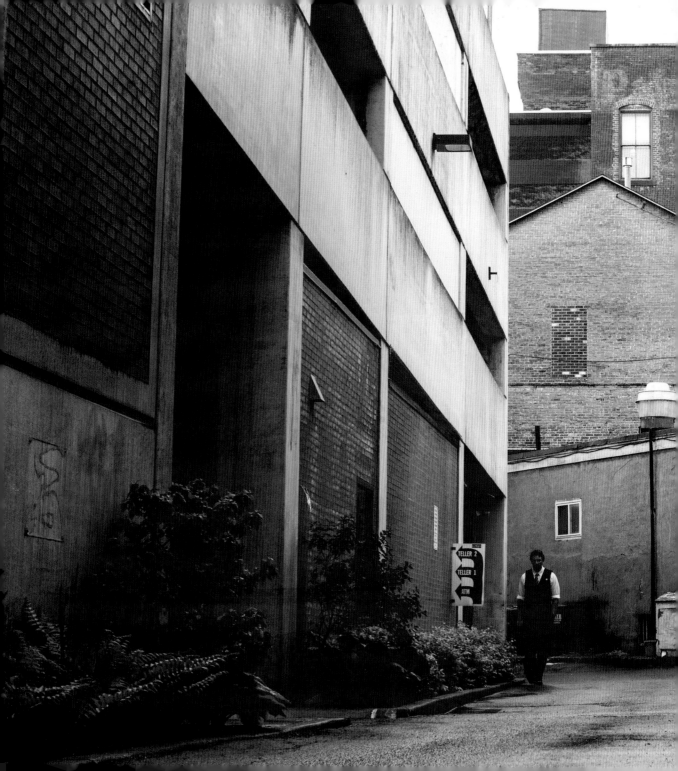

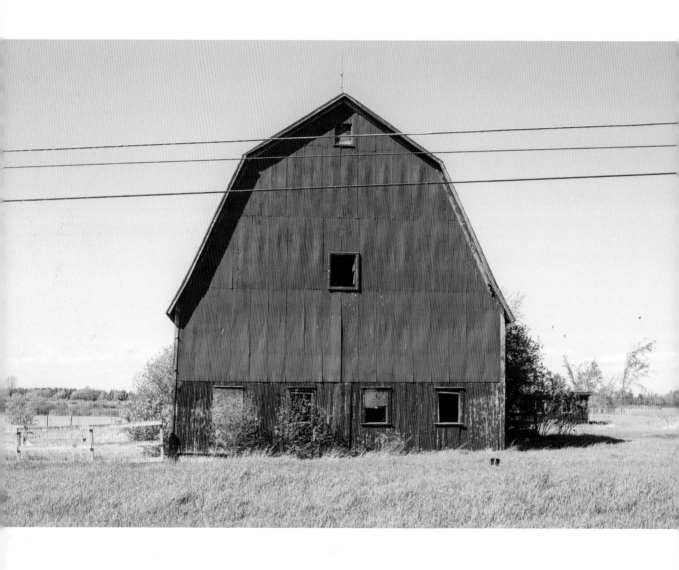

MOMO LOVES:

Rolling around in snow or grass.

MOMO HATES:

Balloons. Loud noises. People wearing big hats.

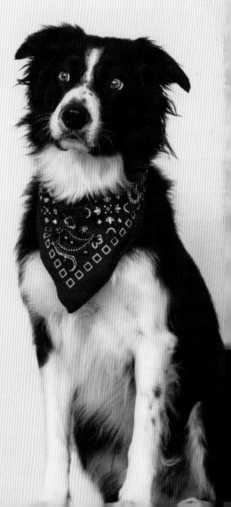

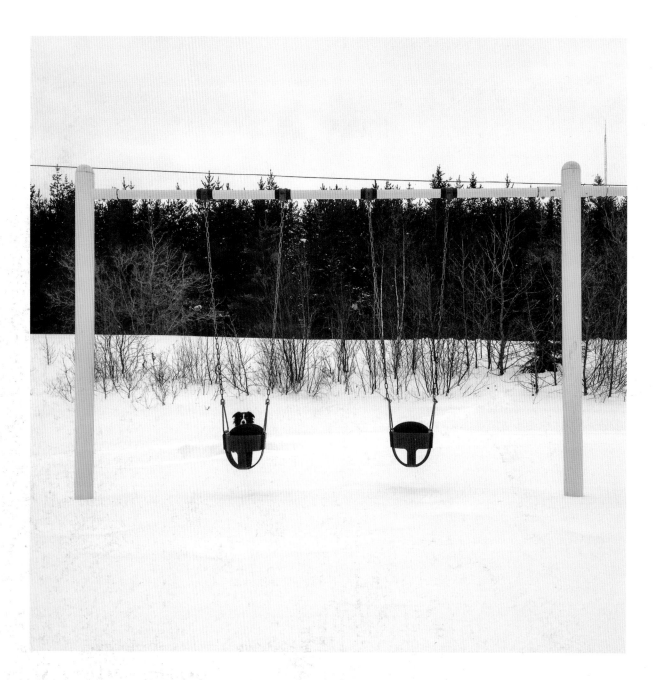

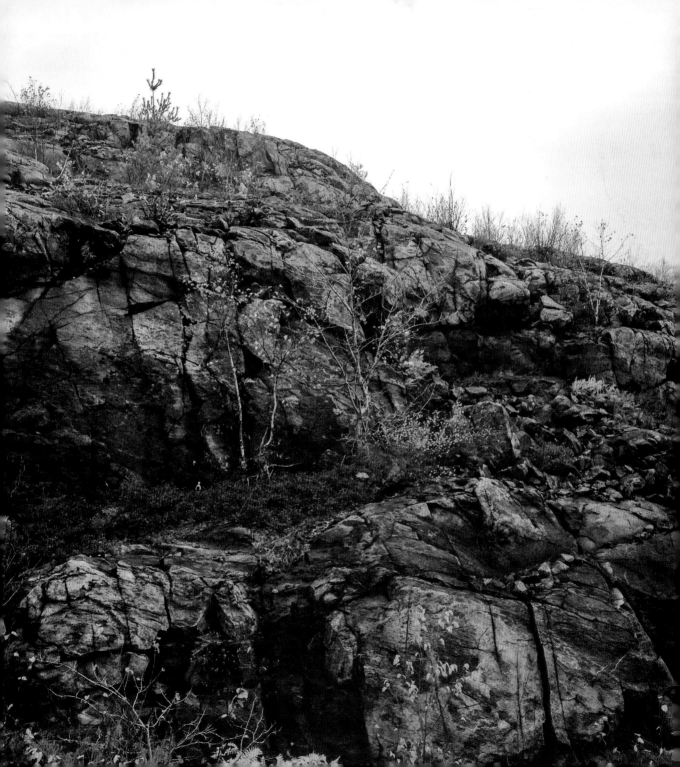

THIS WAS A PARTICULARLY

difficult shoot—for me, at least. It was
very cold, I was wearing jeans, and I had to
trudge through a field of waist-deep snow
to get to the hill. But Momo was happy to
do it. He loves plowing through deep snow!

HINT: The rocks are bigger than you think.

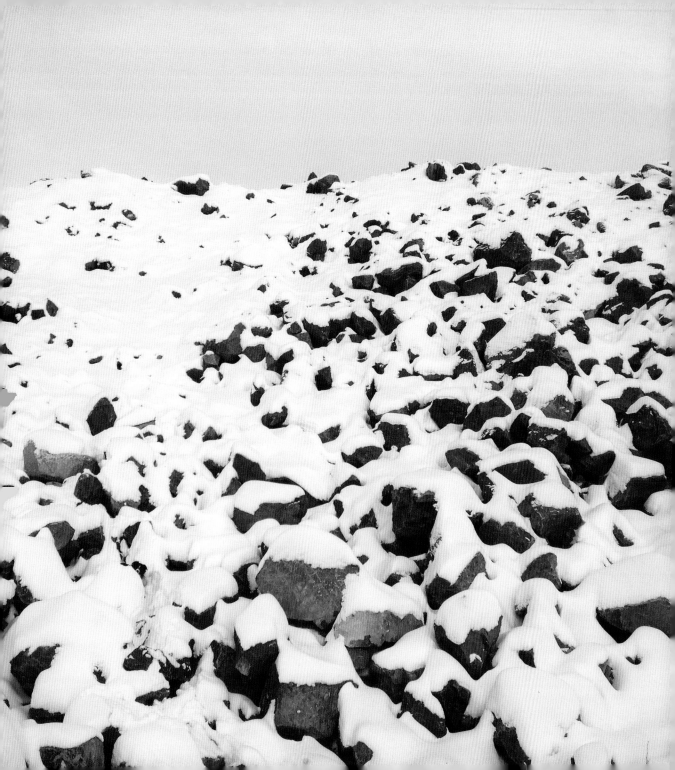

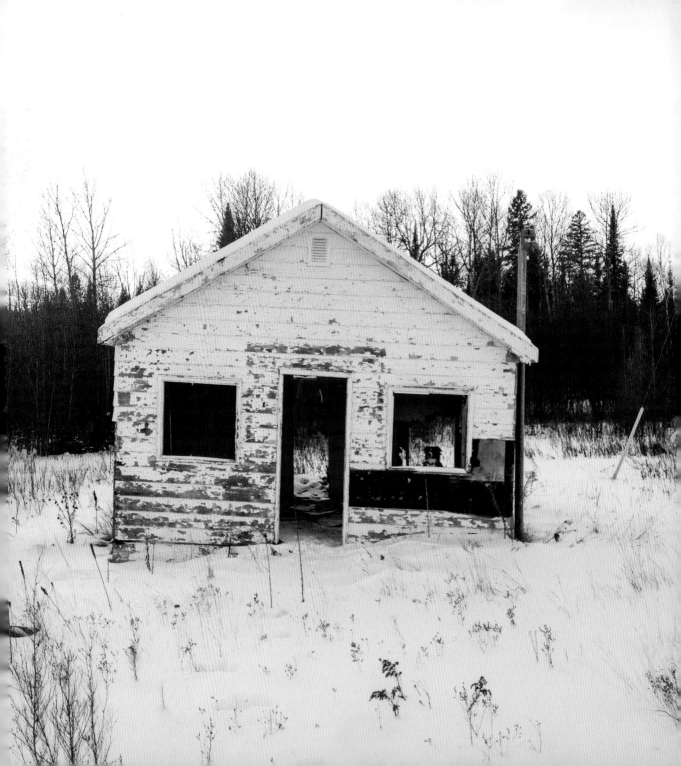

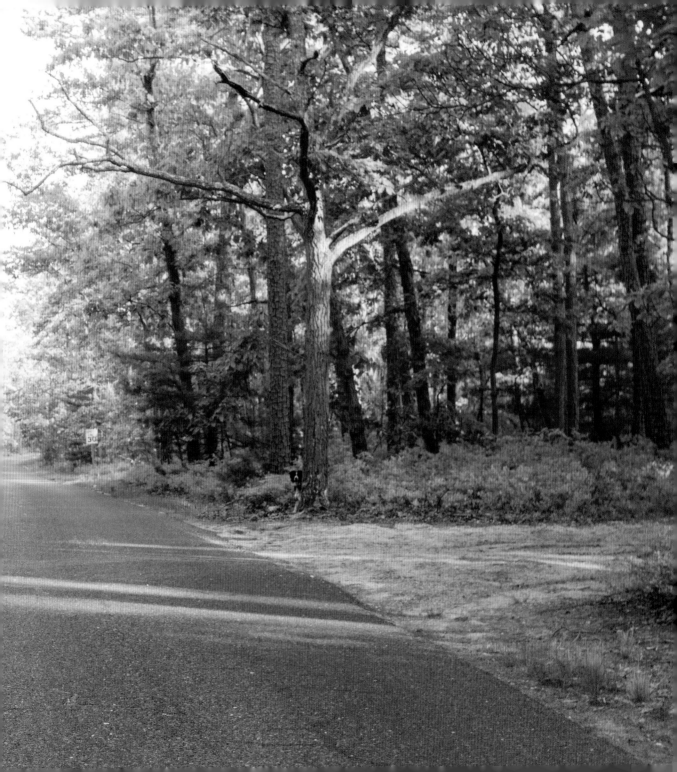

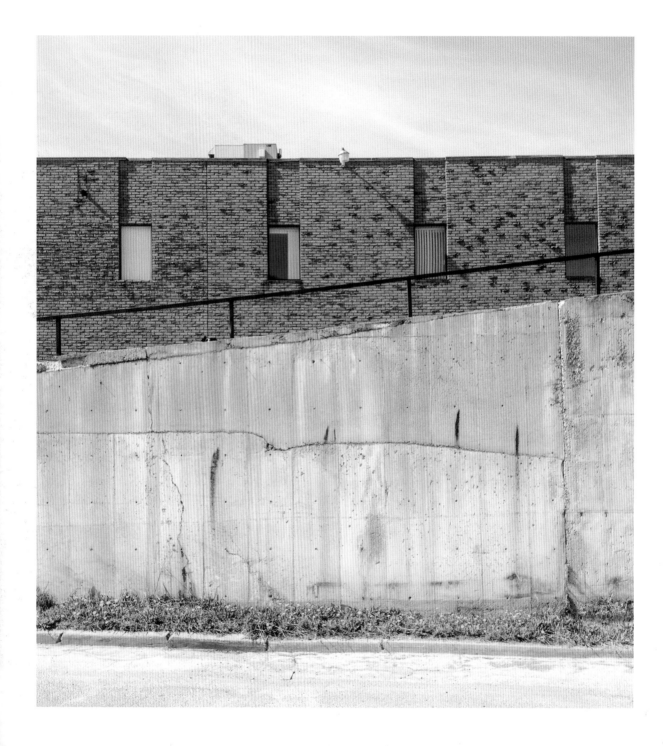

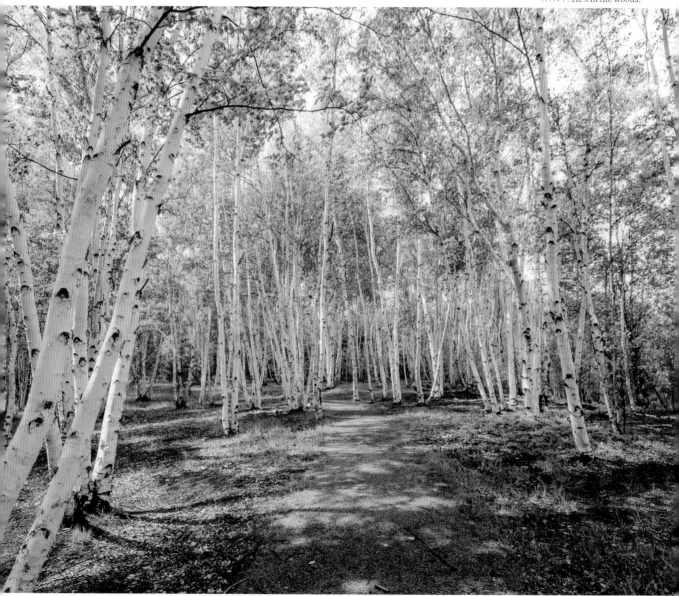

Find Momo

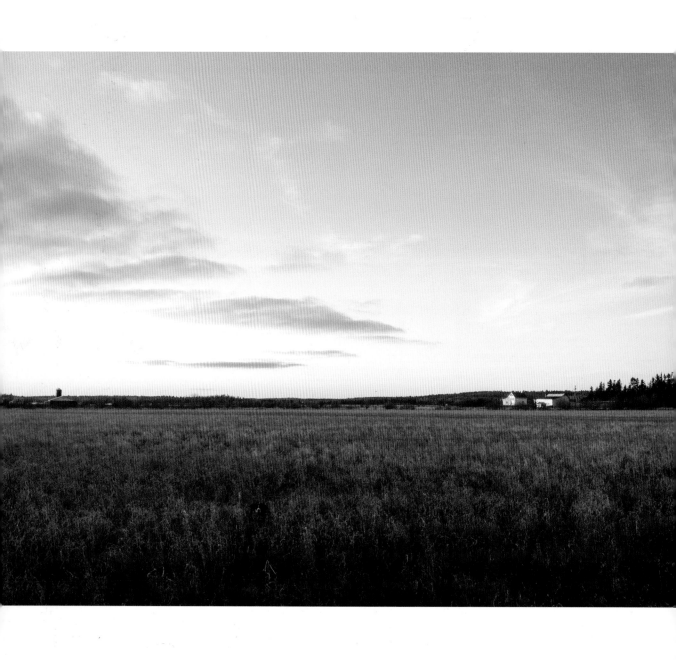

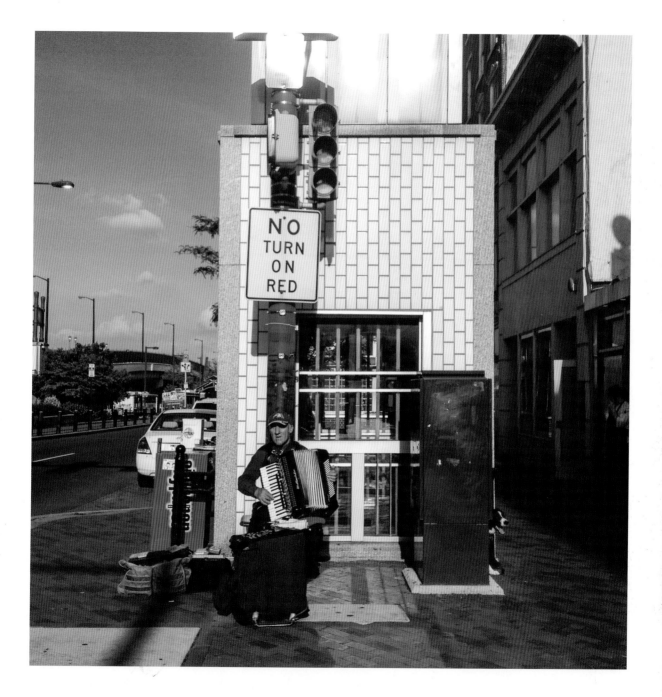

HERE IS MY FRIEND

Pierre's auto body shop.
The place had some weird,
loud noises that freaked
Momo out a bit. Border
collies are notoriously
sensitive to strange sounds.

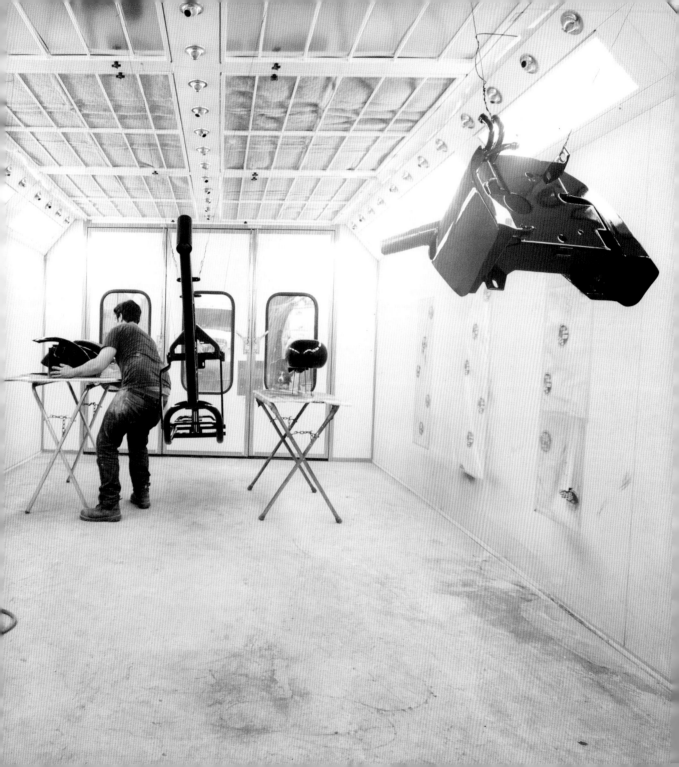

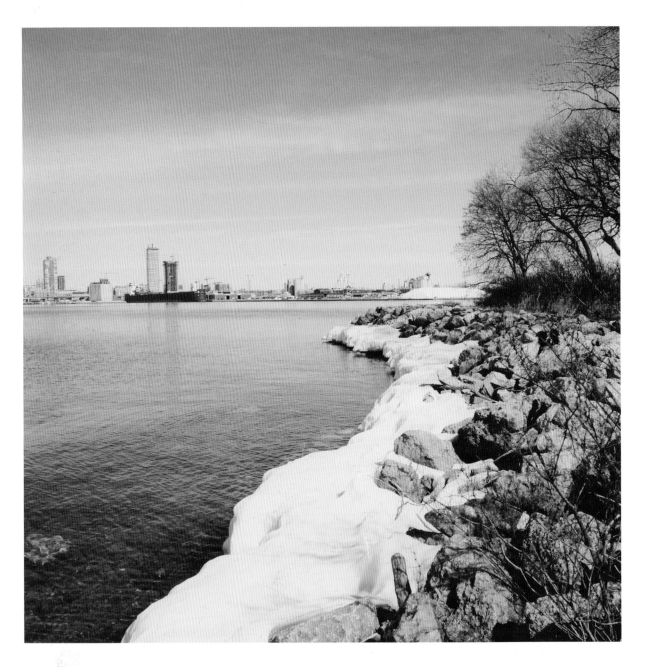

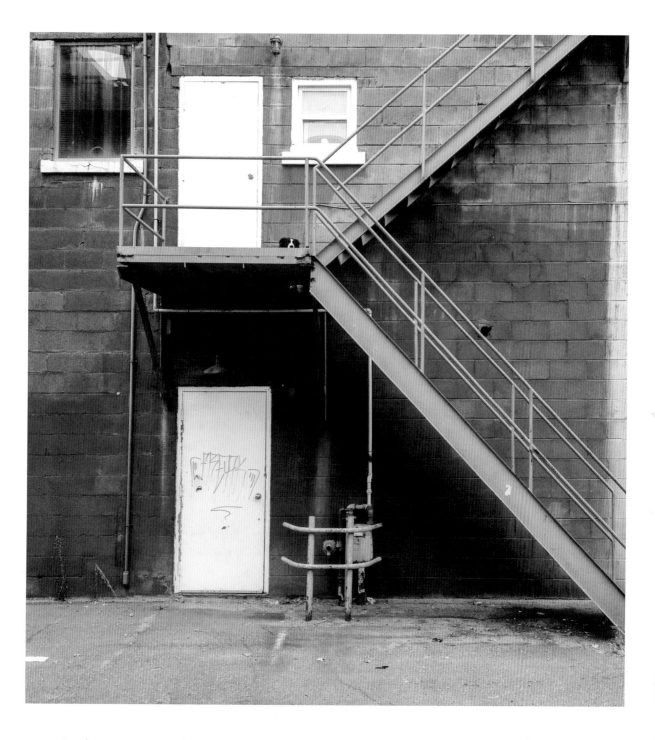

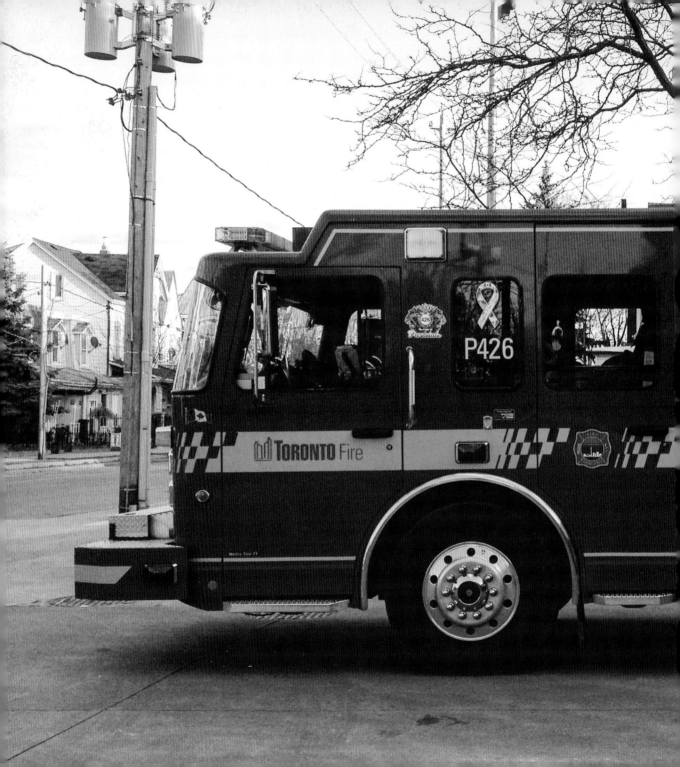

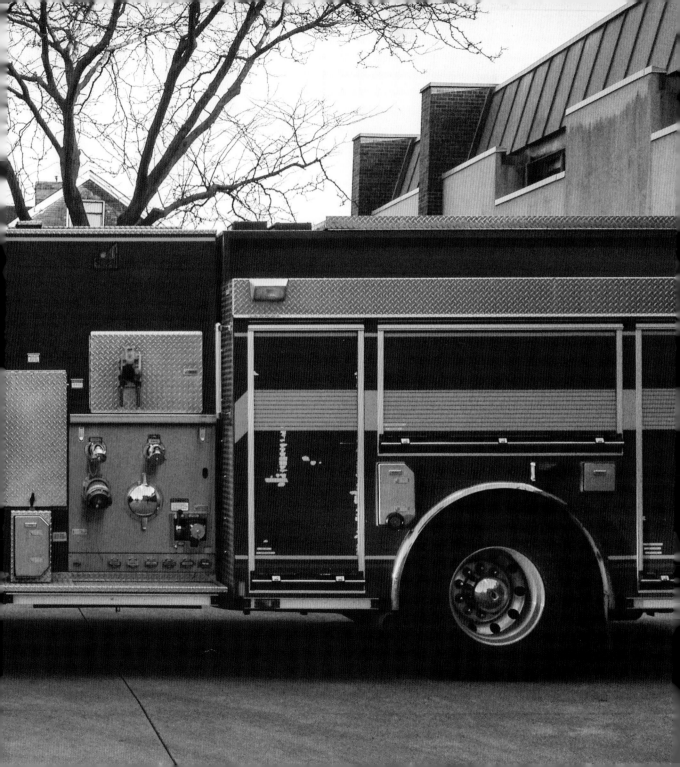

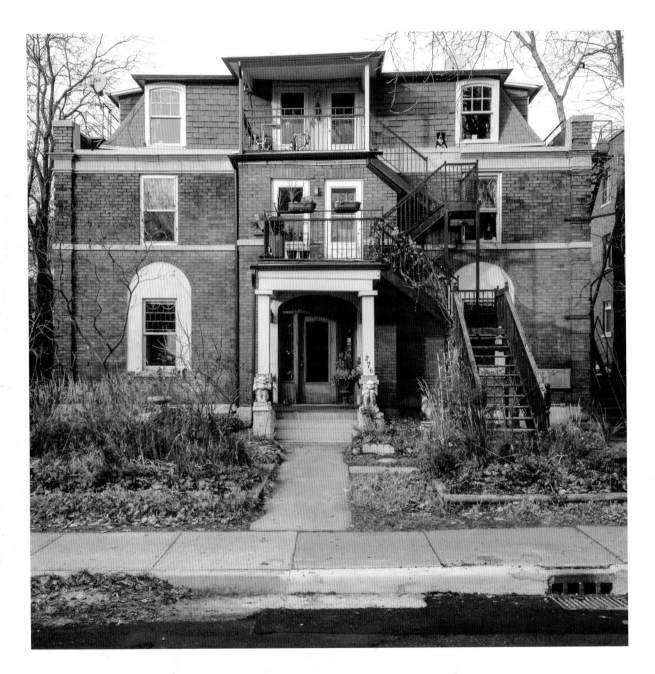

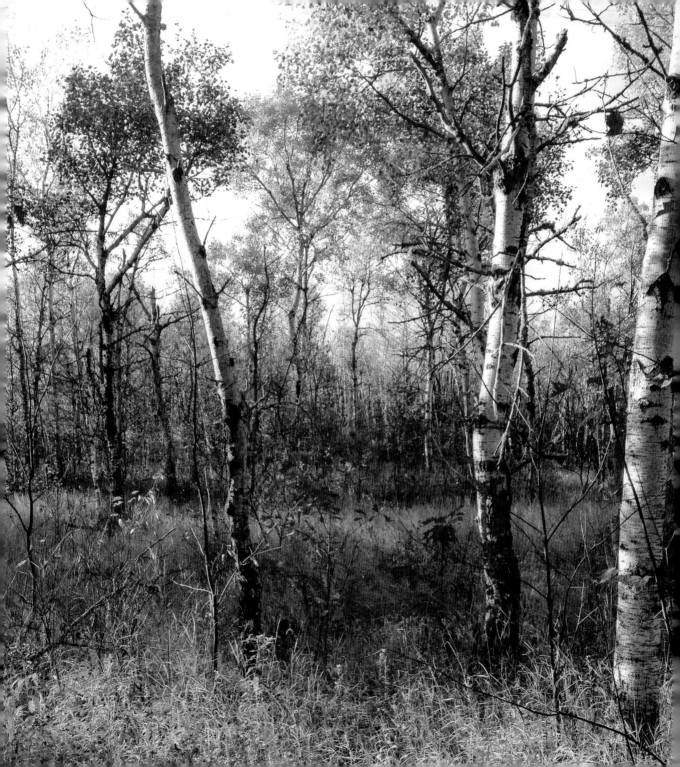

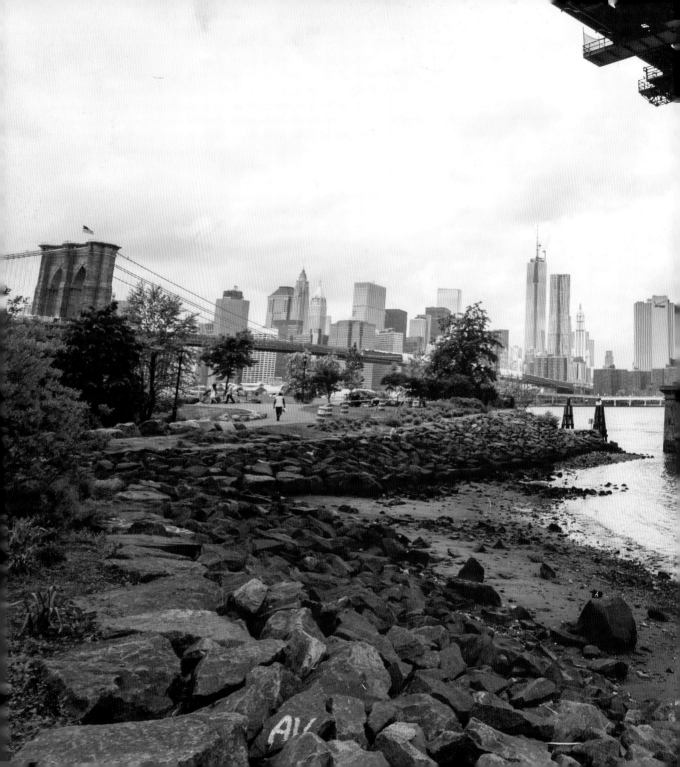

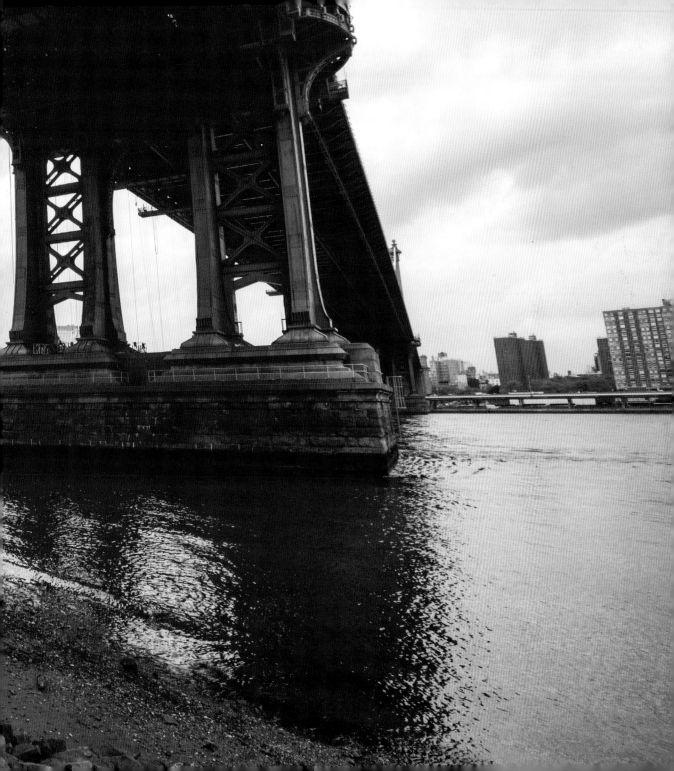

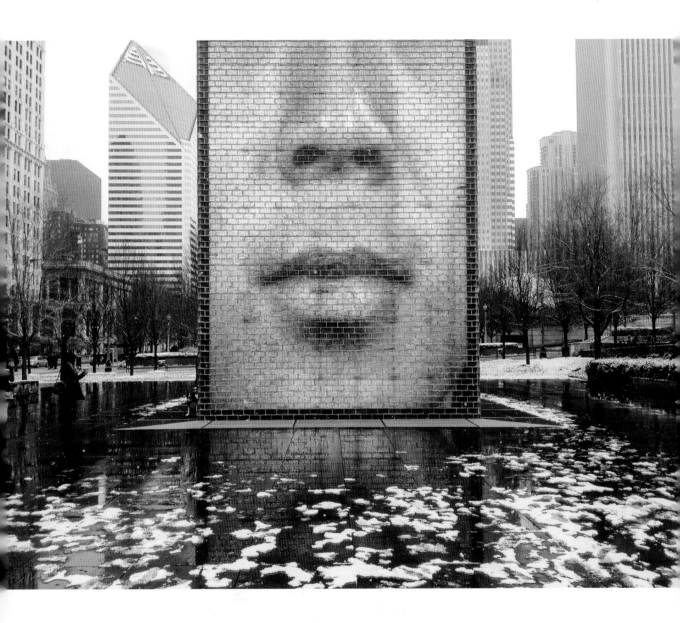

MOMO AVOIDS PUDDLES

or dirt unless he's chasing a ball—or
in work mode, in which case he'll run
through anything.

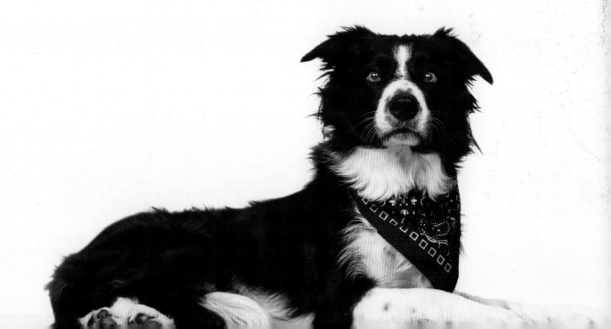

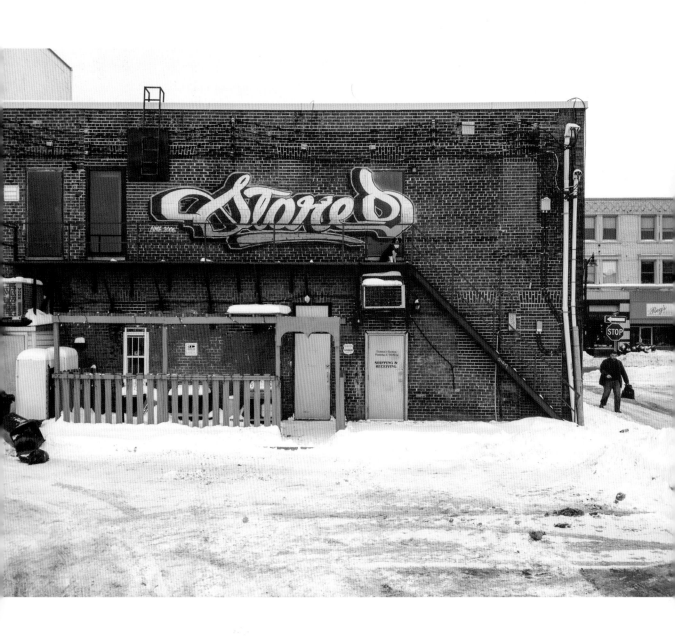

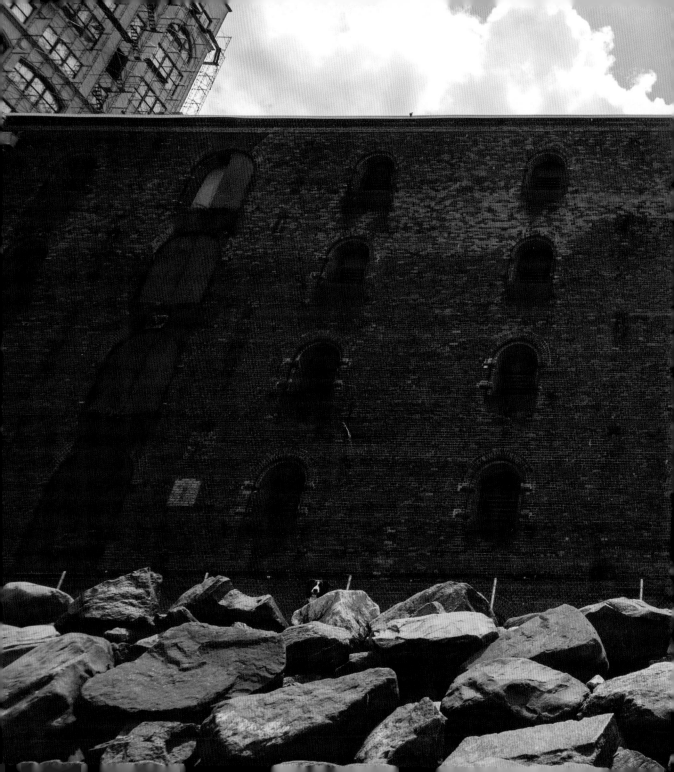

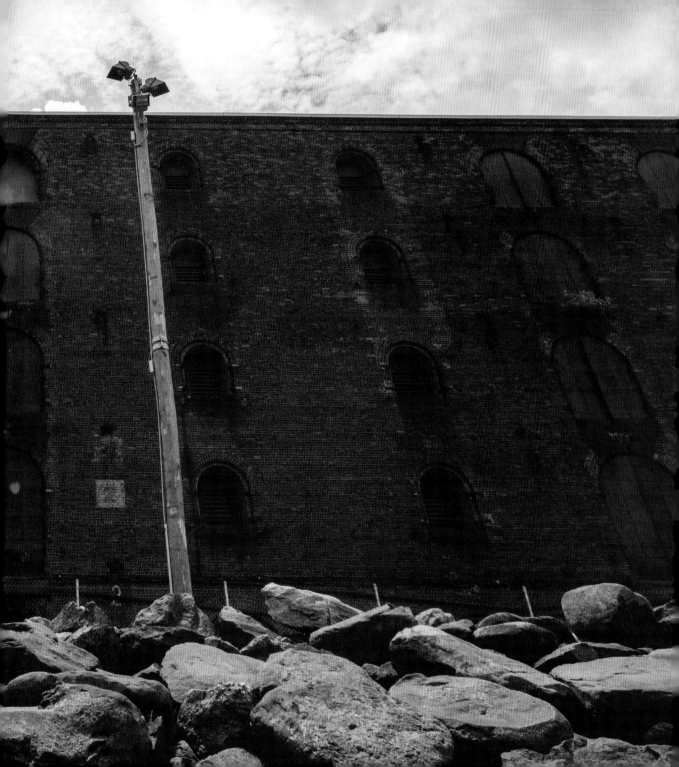

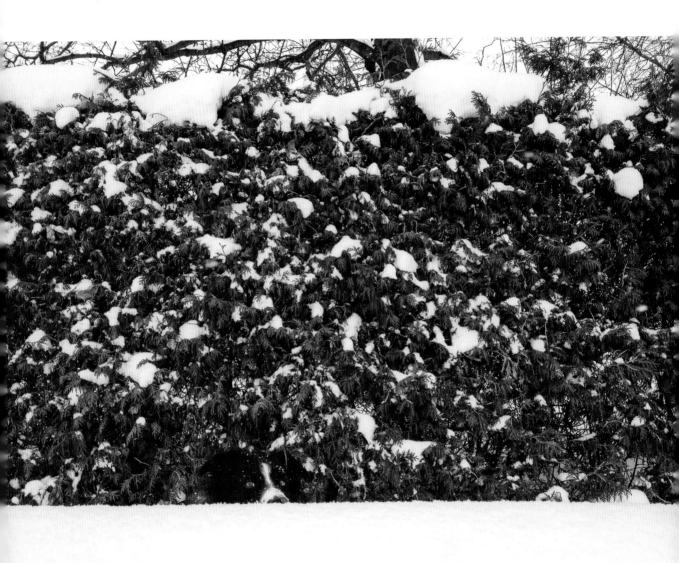

ALONG WITH HIDING, MOMO knows the usual assortment of canine tricks (sit, stay, paw, high-five, roll over, speak). He is pretty good at balancing things on his head or in his mouth. He's also been known to climb trees, and he jumps like a stuntman!

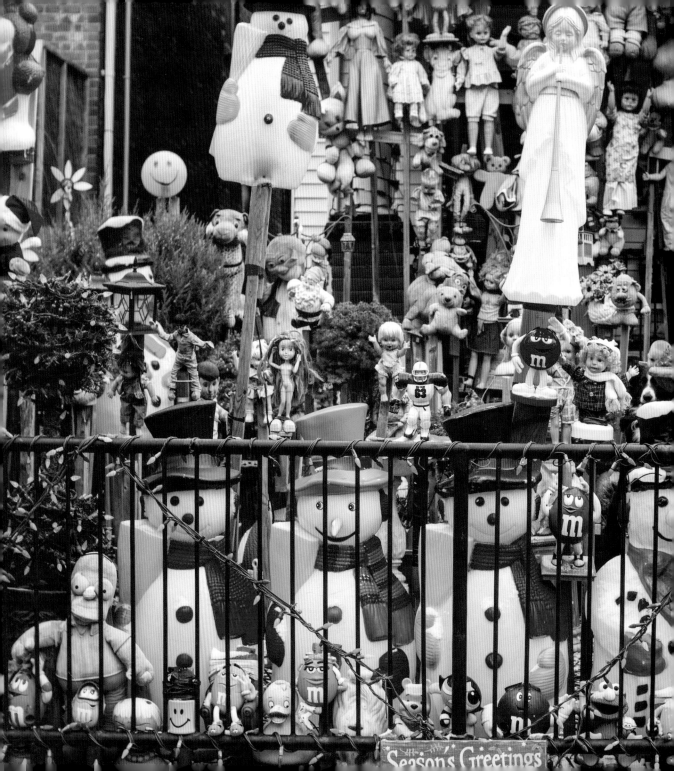

Season's Greetings

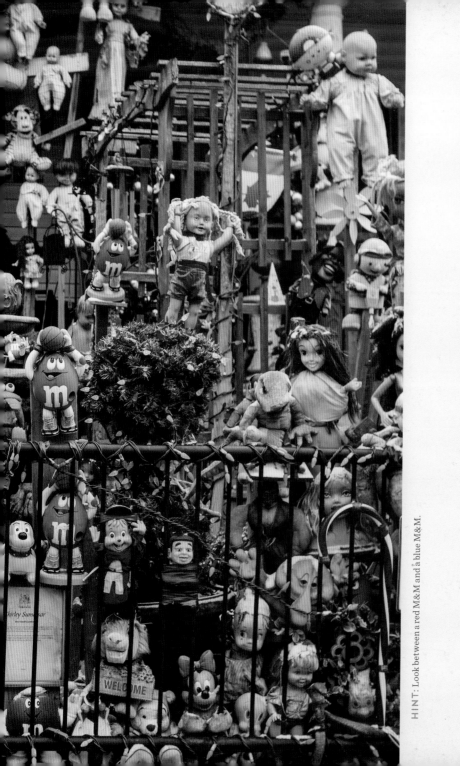

HINT: Look between a red M&M and a blue M&M.

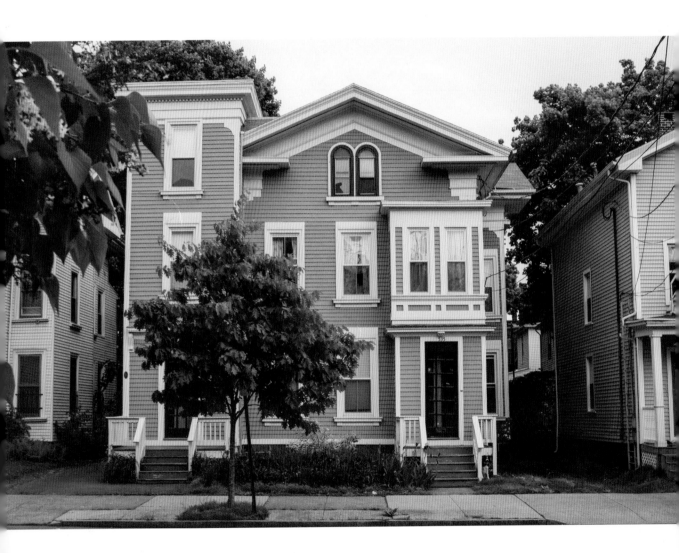

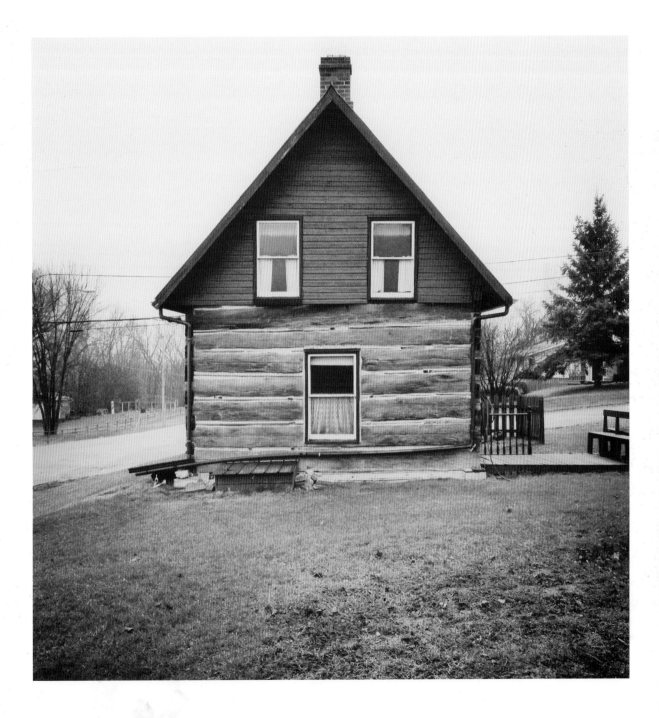

MOMO MAKES FRIENDS WITH
just about every dog and human he meets.
But he has a funny relationship with cats.
Simply hearing the word "cat" will send
him on a wild hunt. If he encounters a cat,
he may stare at it for hours.

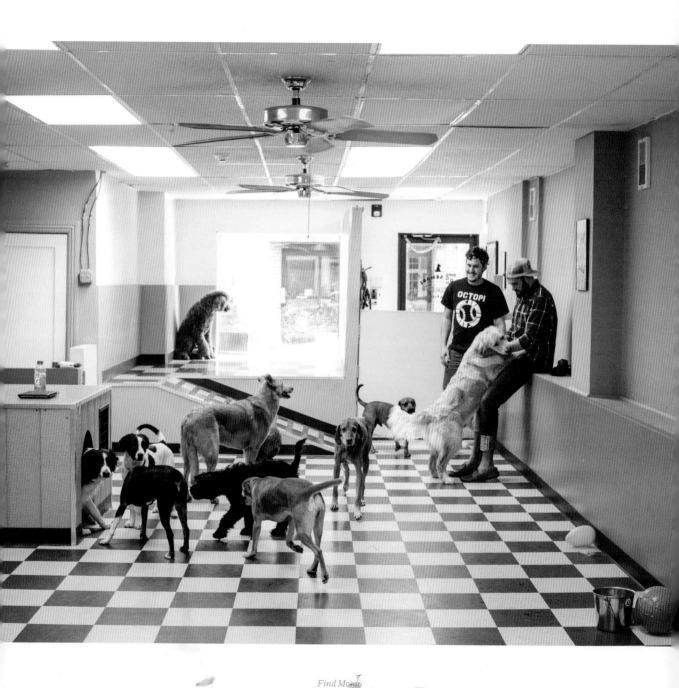

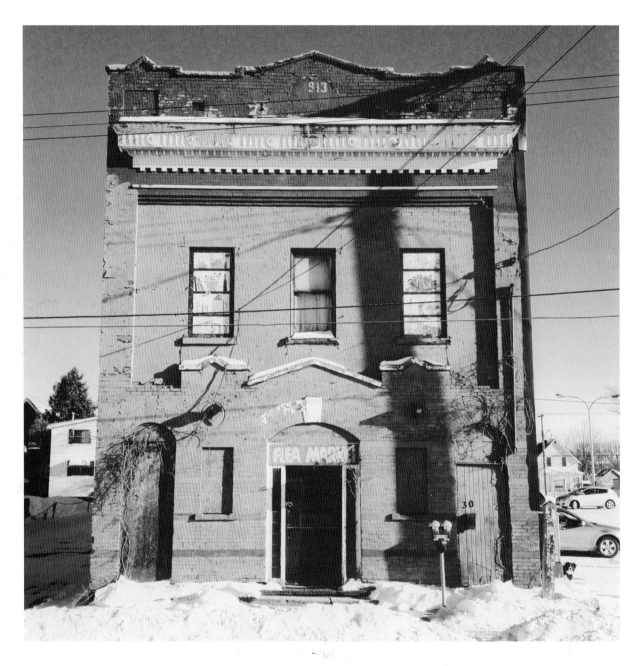

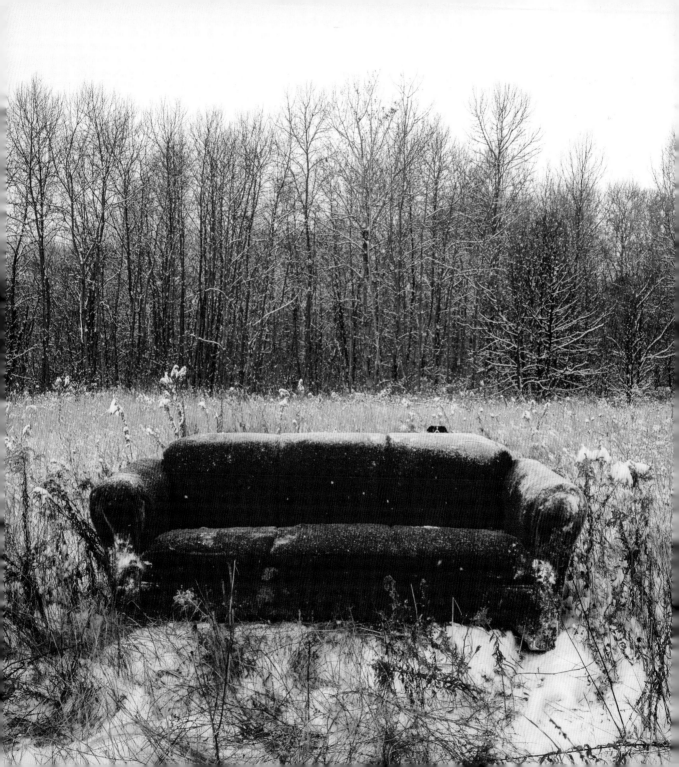

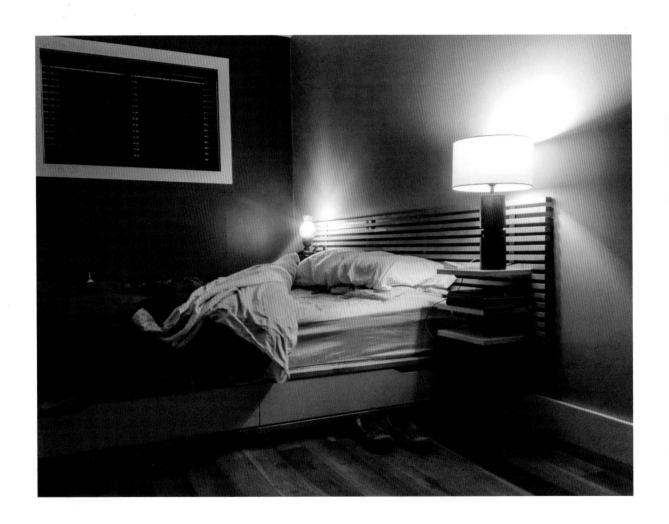

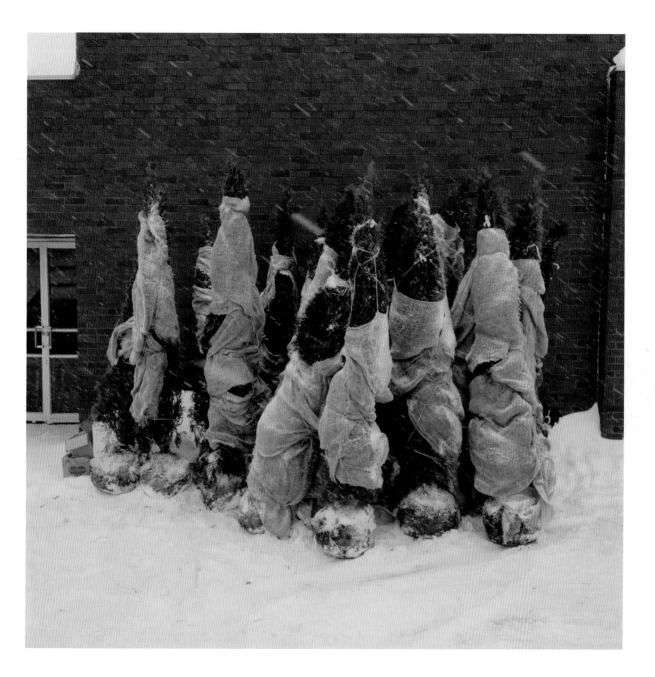

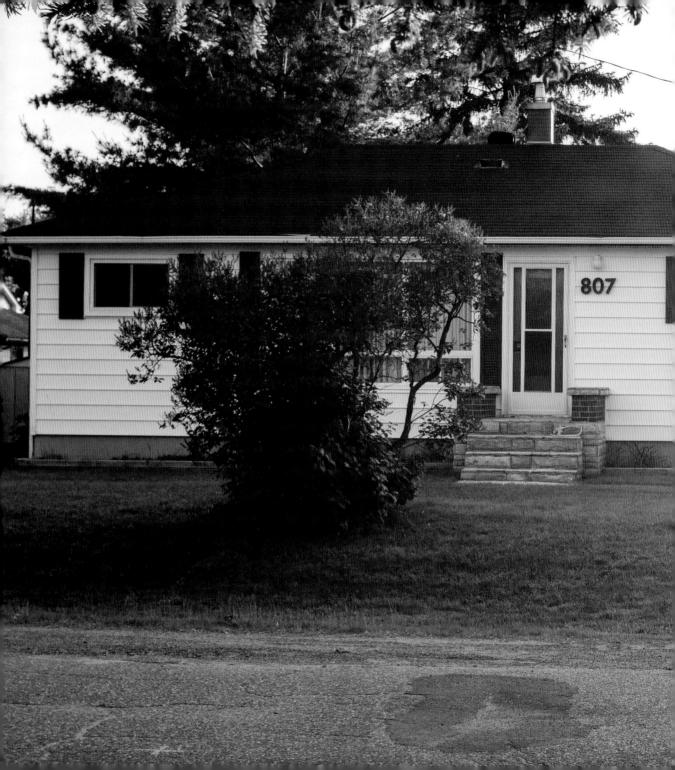

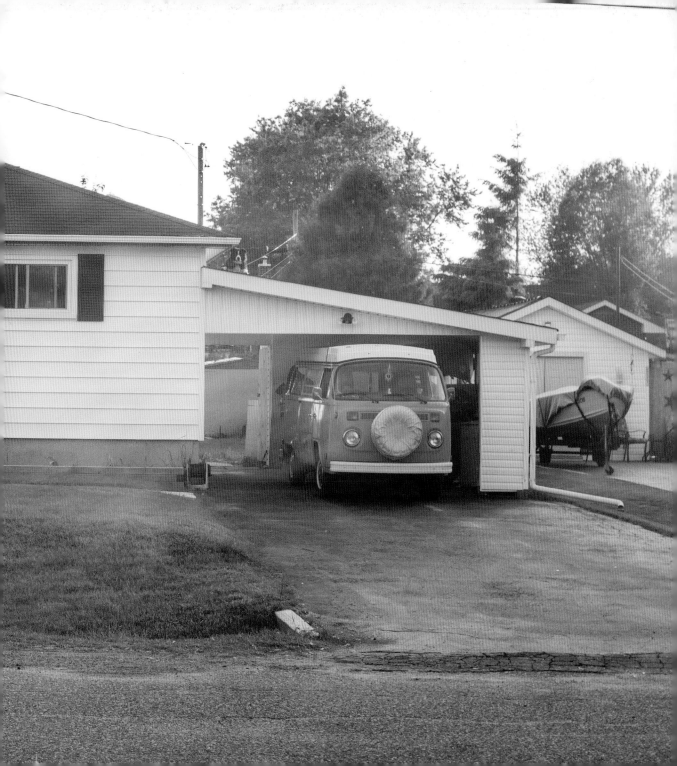

THIS IS THE CANADIAN SPORT

of curling, specifically an at-home version practiced by friends of mine on a frozen lake near their house. Momo likes chasing the "stones" (jugs of frozen water, really) a little more than I hoped he would. But he is Canadian raised, after all.

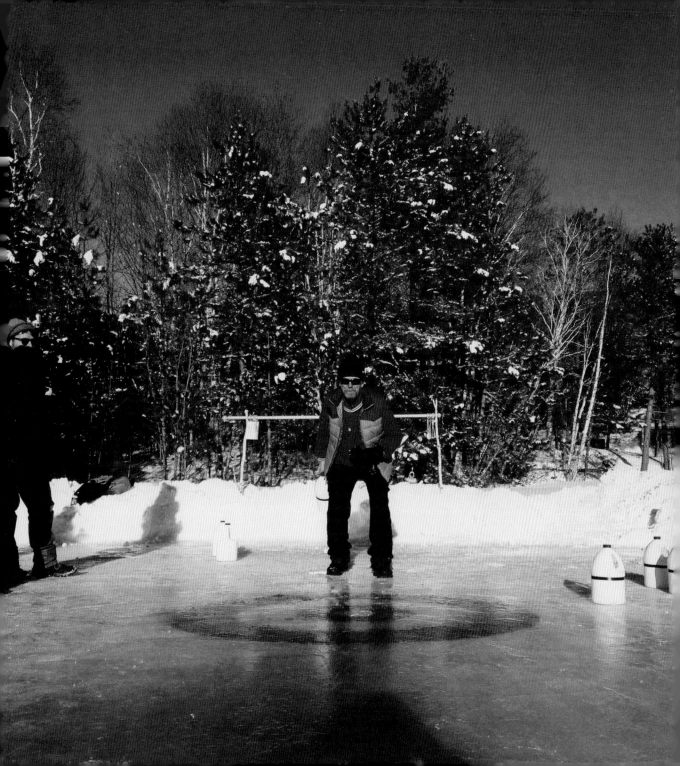

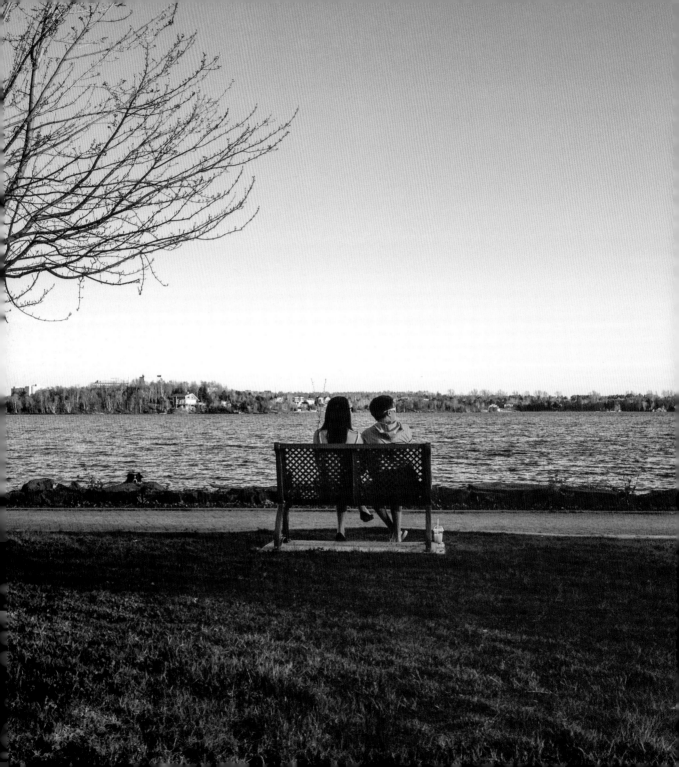

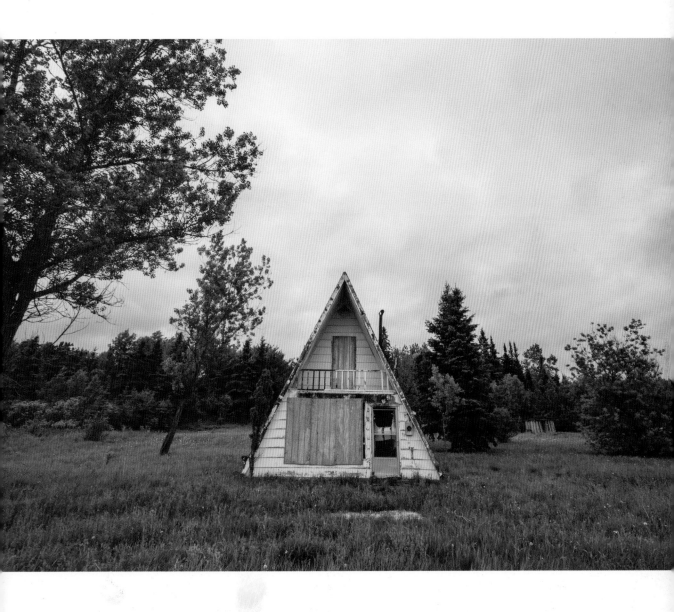

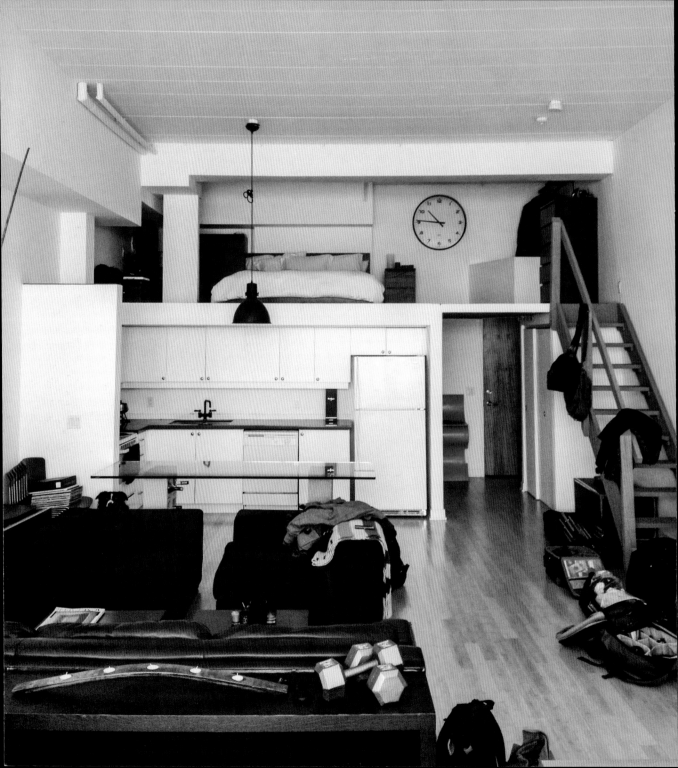

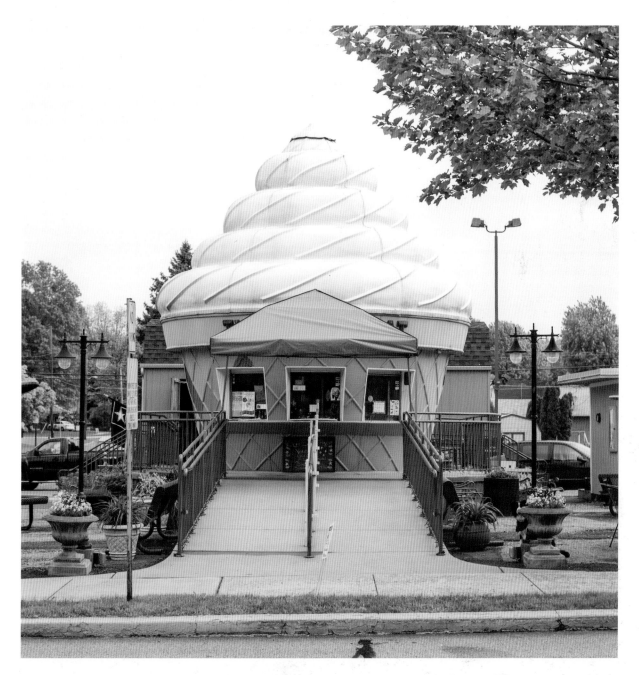

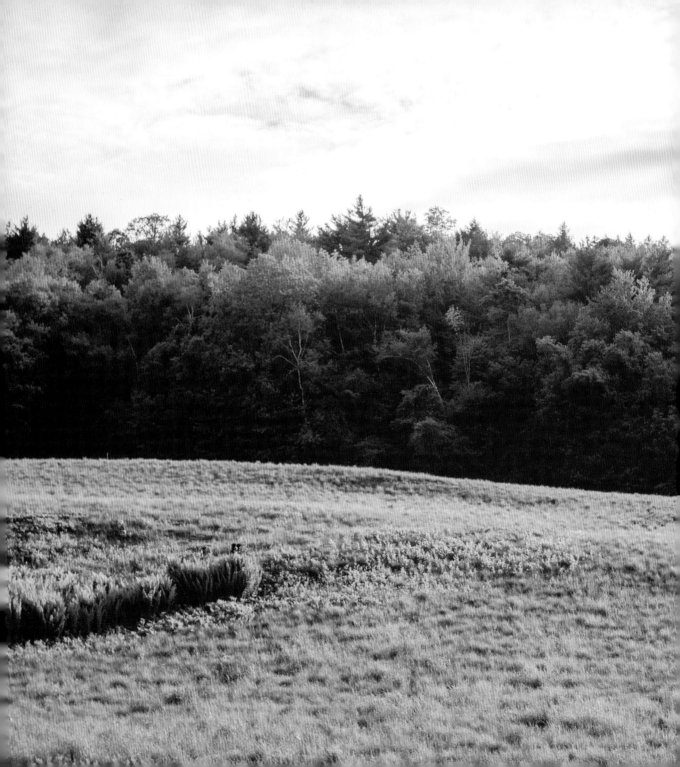

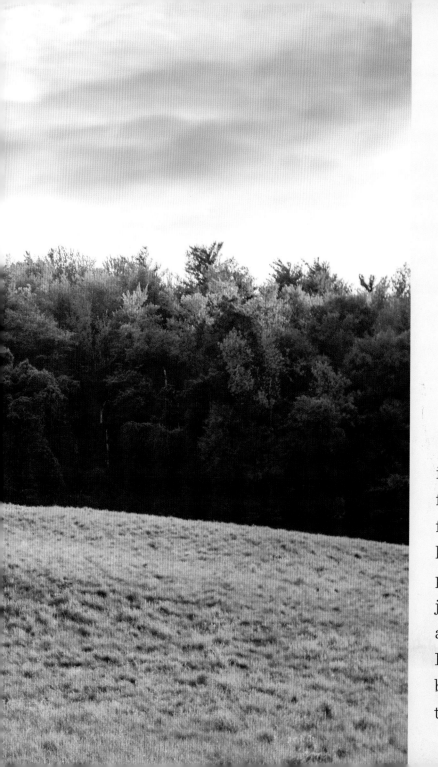

RUNNING AROUND

in circles in fields or forests is one of Momo's favorite things to do. Put him in a fenced-in dog park, and he'll want to jump the fence and run around it. His friend Razor, another amazing border collie, taught him the fence-jumping trick.

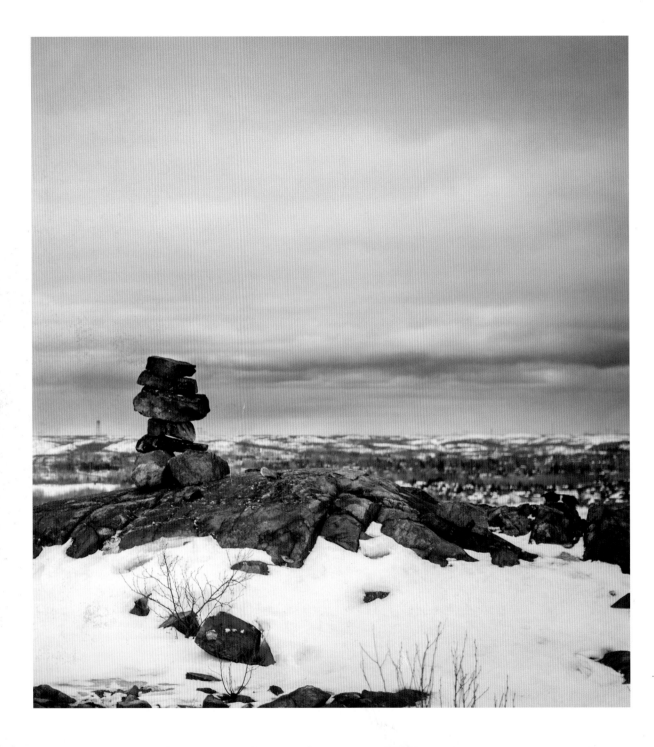

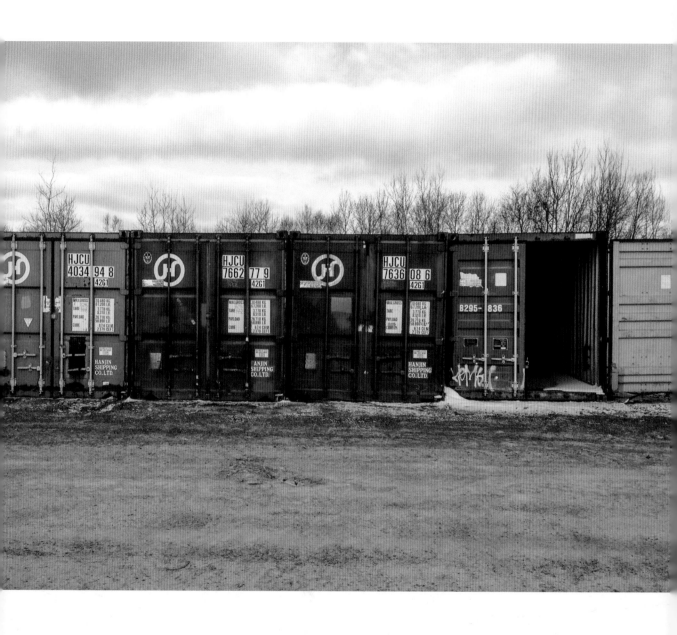

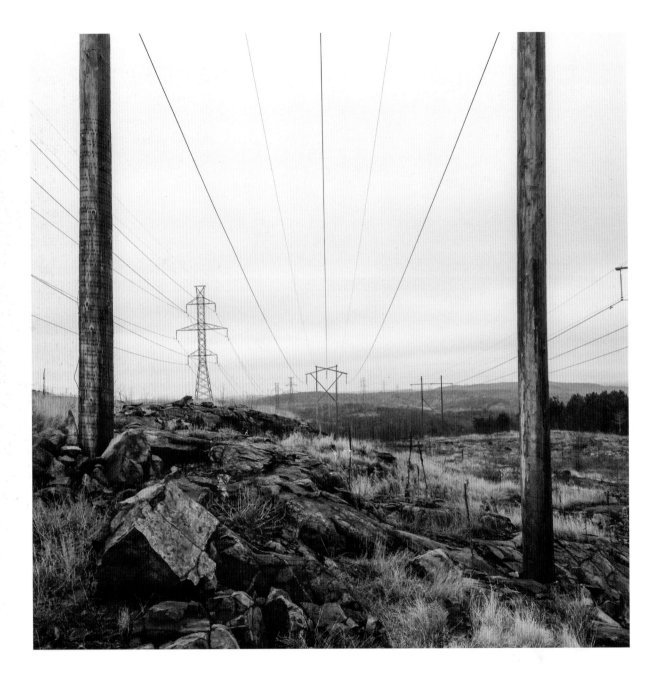

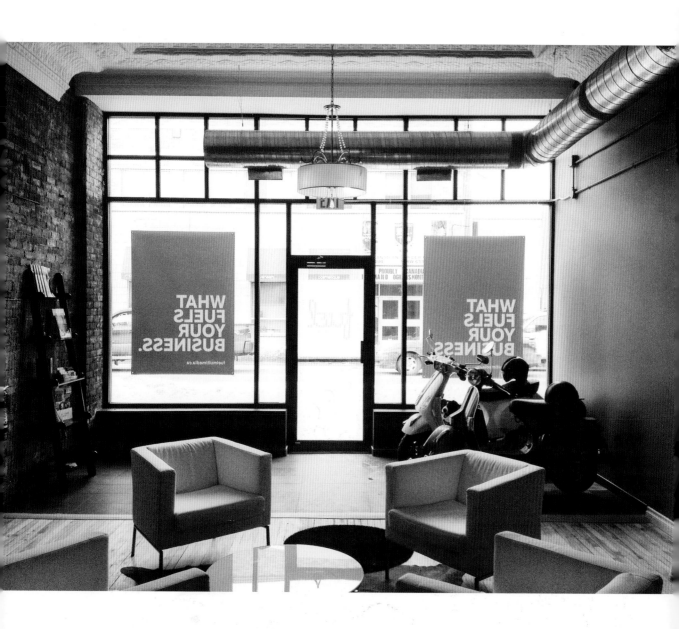

MOMO EARNED A SMATTERING

of applause from the patrons of this outdoor-gear shop. Though really he had no problems navigating the fake landscape. He treks through forests all the time.

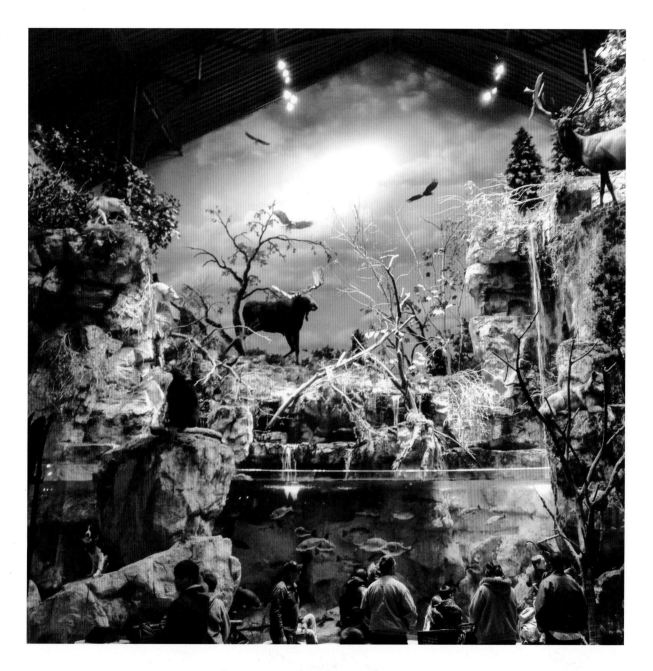

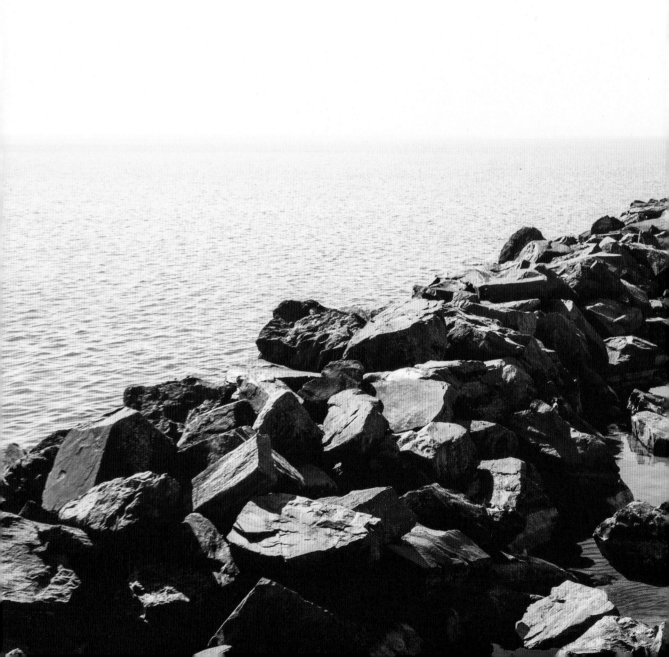

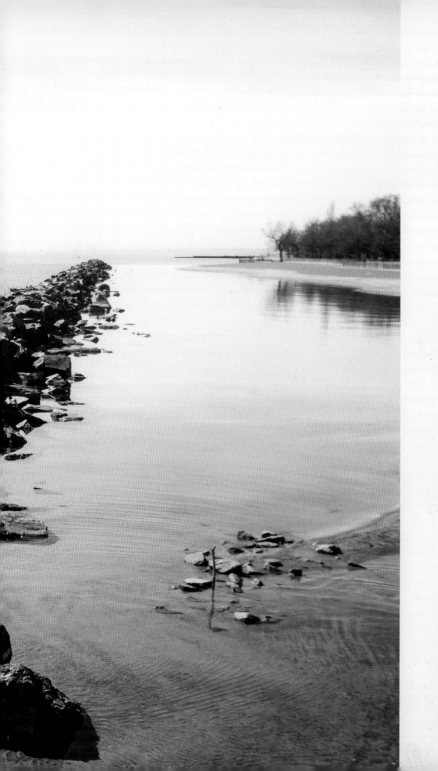

I WAS VERY FAR

away from Momo for
this shot, so it was extra
impressive that he stayed
put and didn't move a
muscle. When I called
him afterward, he blasted
right back to me and
seemed extremely proud.

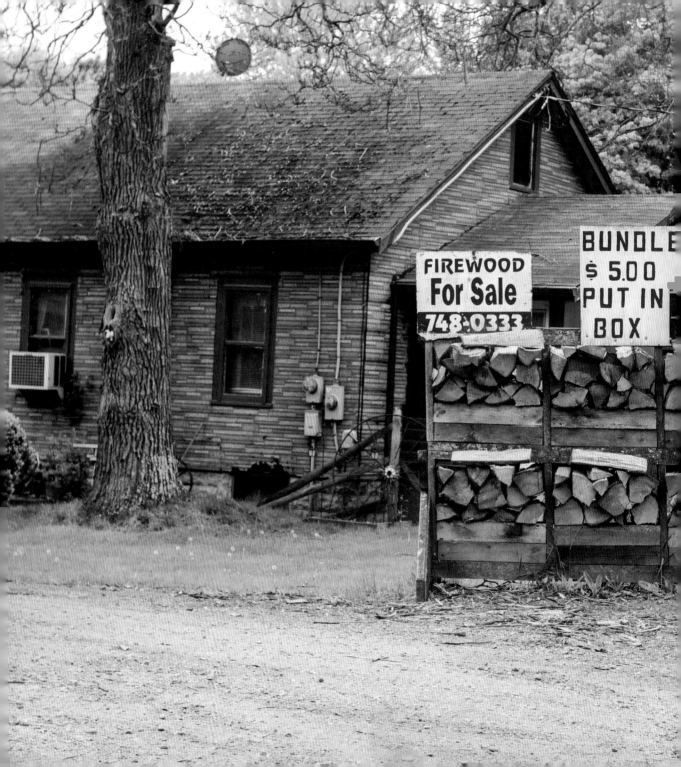

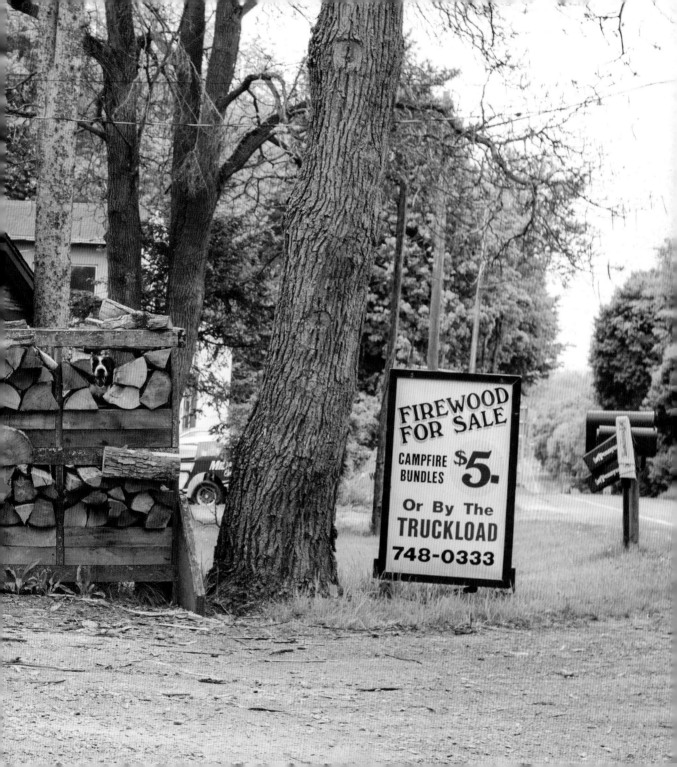

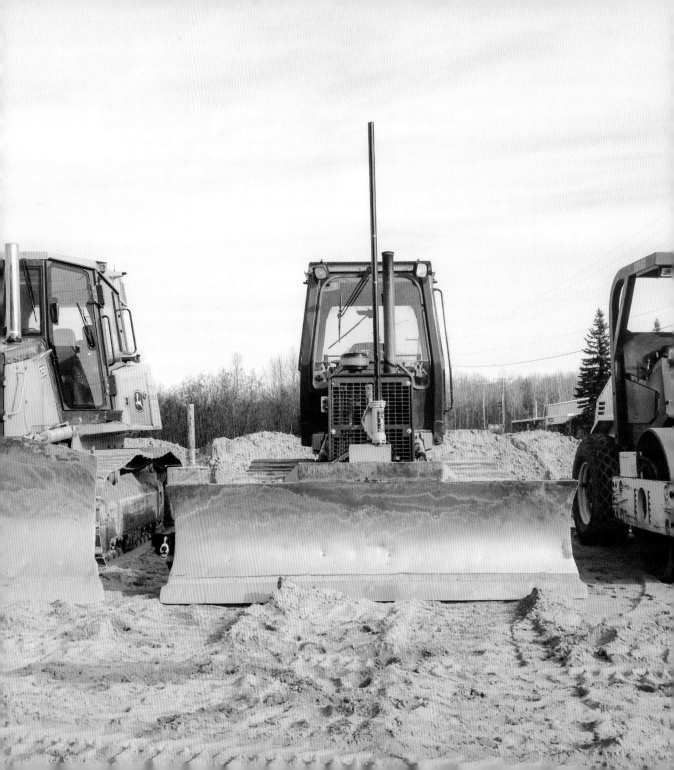

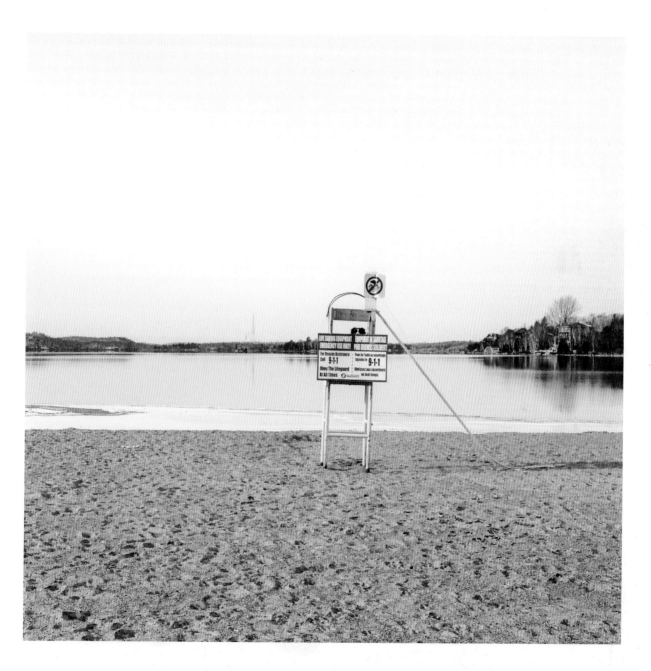

Find Momo

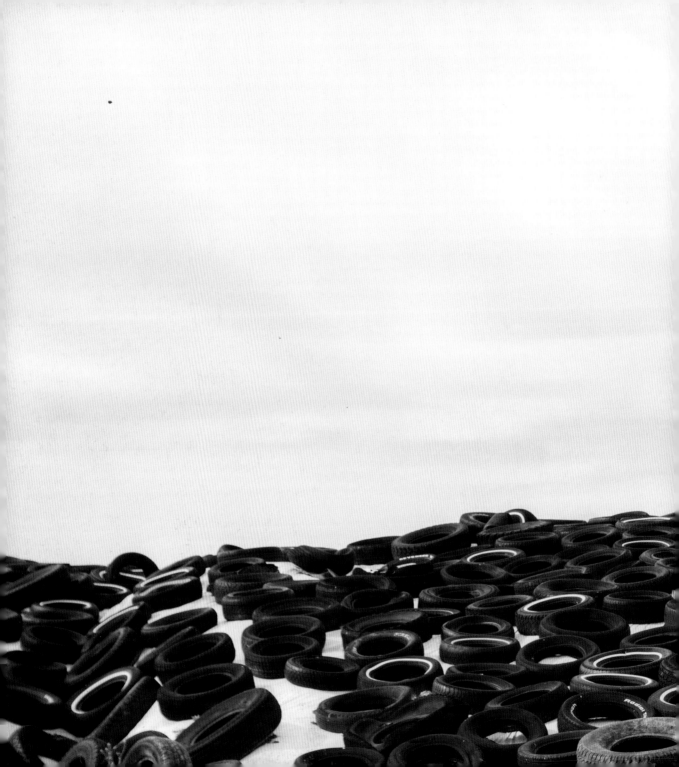

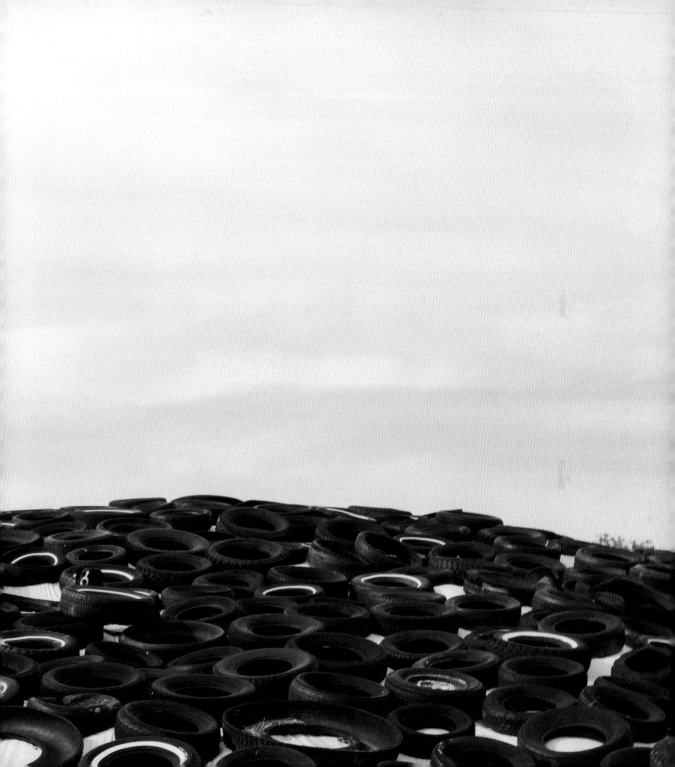

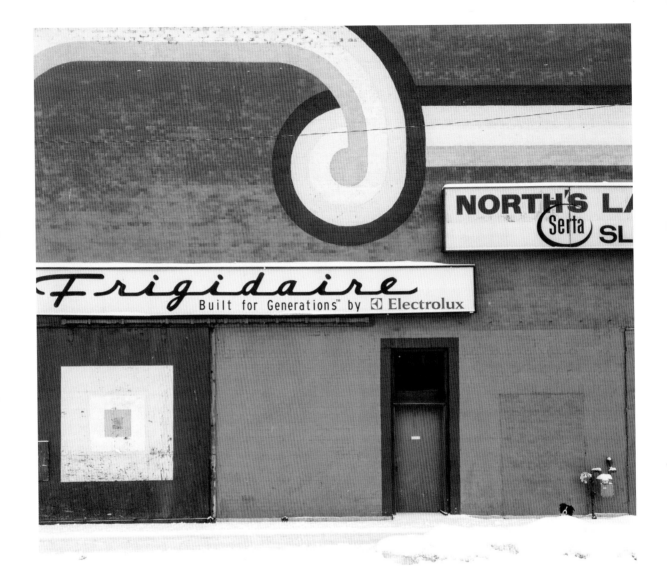

MOMO IS A HABITUAL HEAD

tilter. Particularly funny words or sounds will cause him to cock his head first to one side, and then the other.

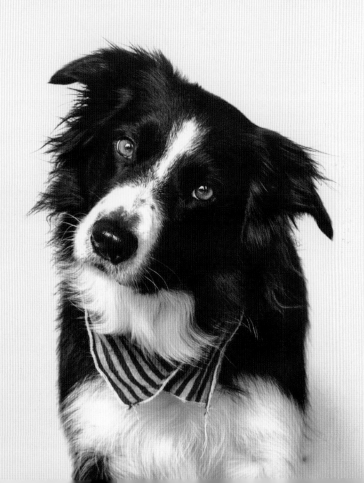

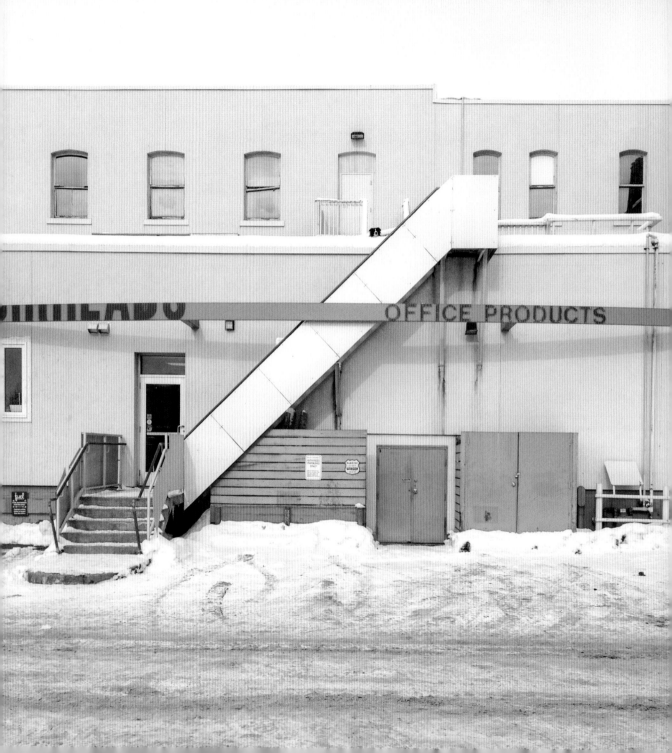

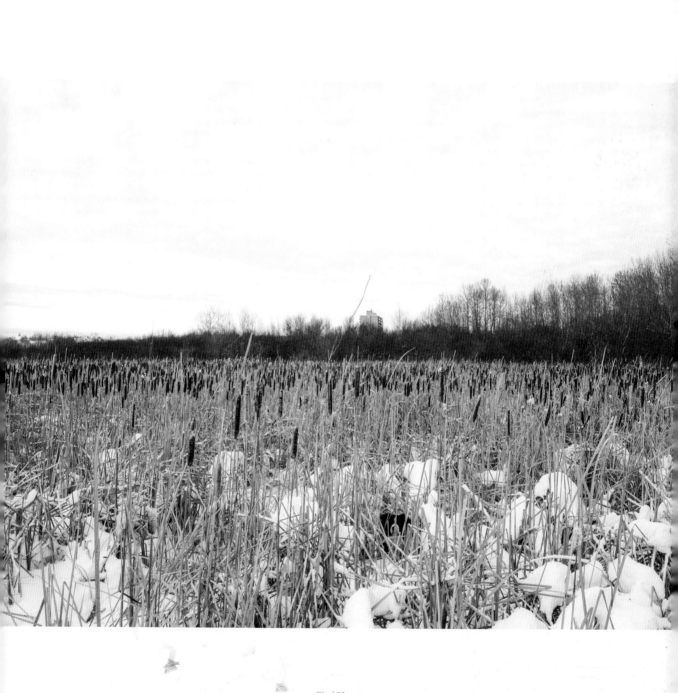

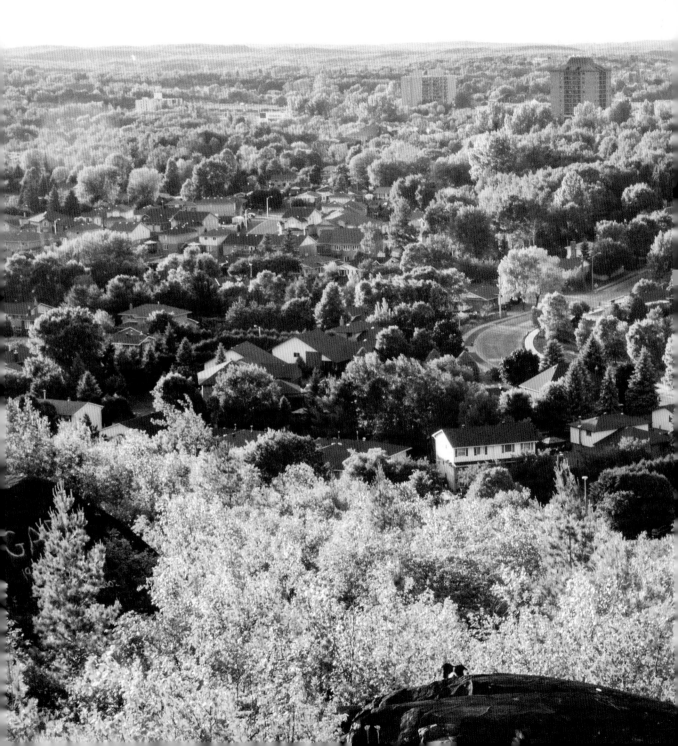

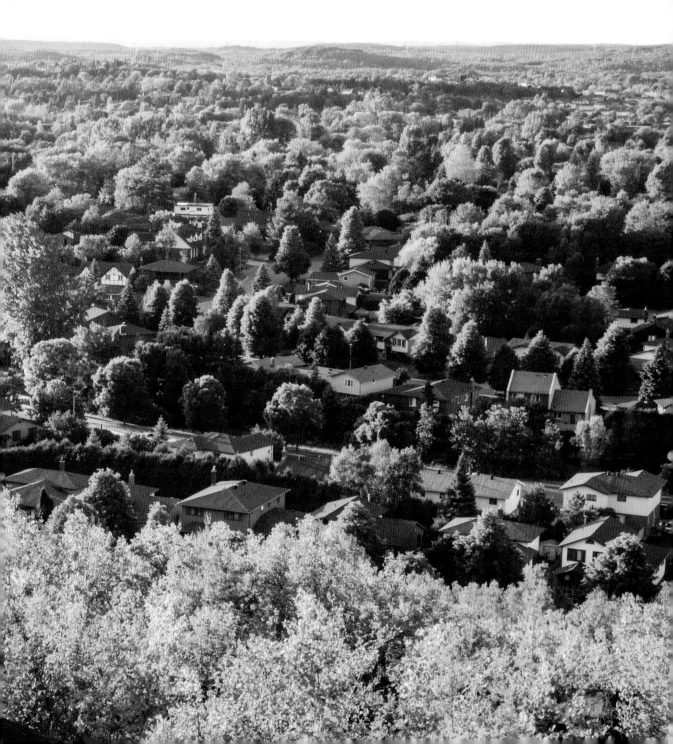

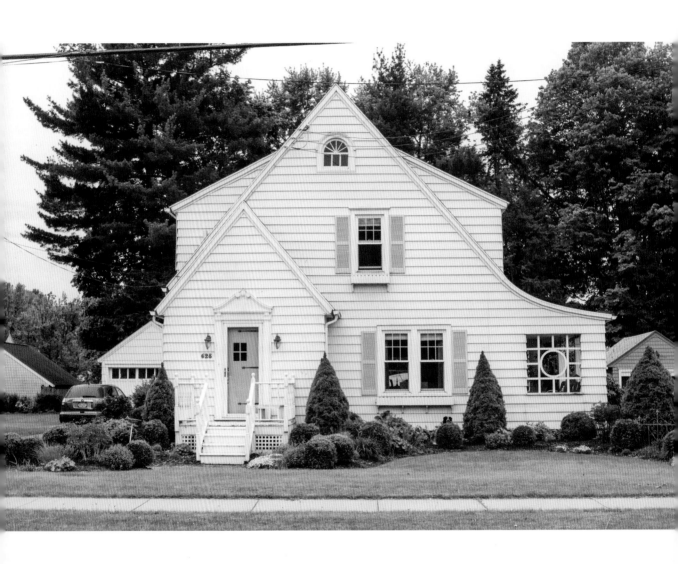

THIS HOUSE IS IN RURAL upstate New York. The lovely owner was flattered when I asked to photograph Momo in her yard, but she wanted us to wait until the lawn guy came to get rid of the weeds! We couldn't wait, and the lawn looks great anyway.

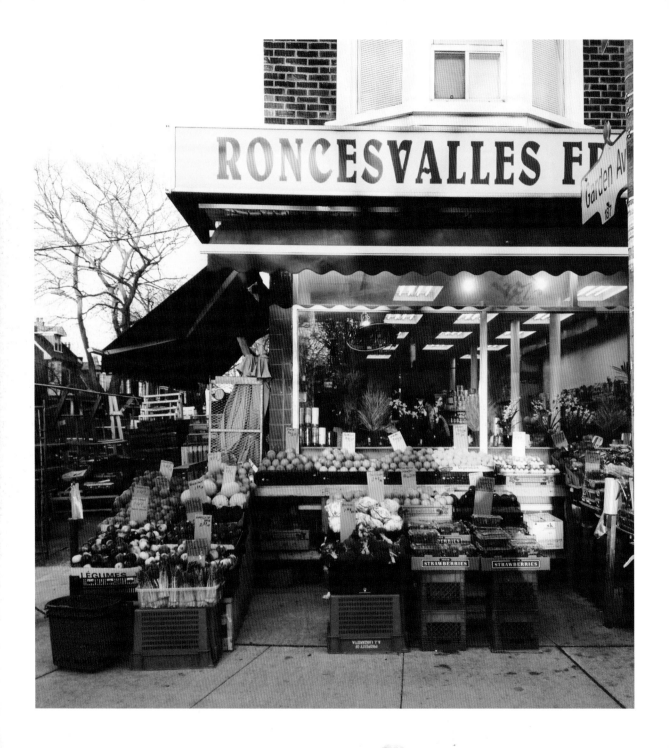

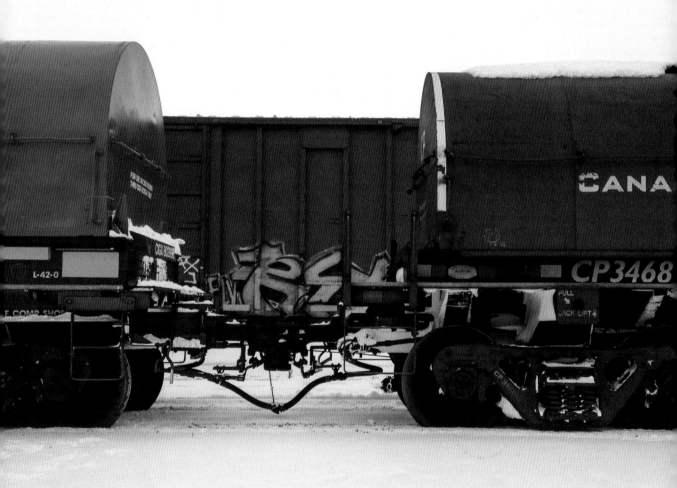

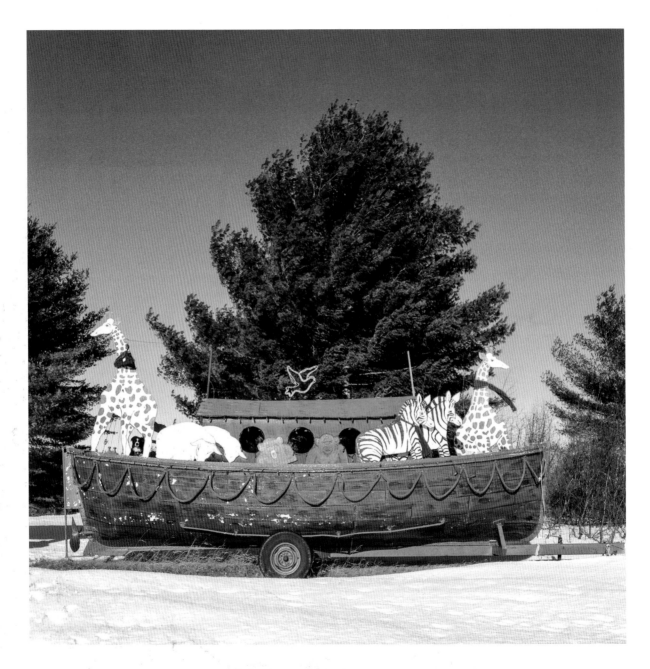

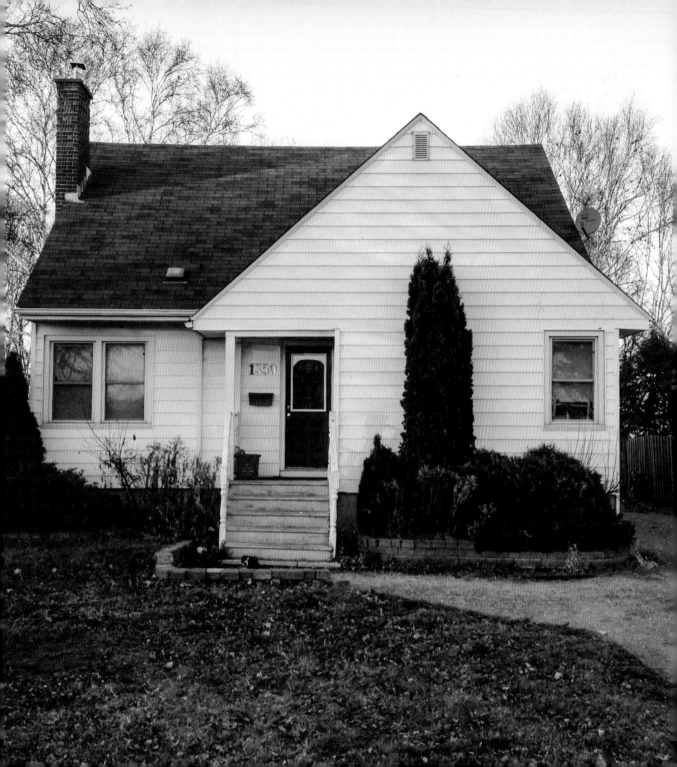

THE PINK CHARACTER IS MY friend Matthew. When he mentioned his mom had a caterpillar costume that had been passed around his family for years, well, it sounded like a good photo idea to me. Momo, as usual, was unfazed. His focus is amazing.

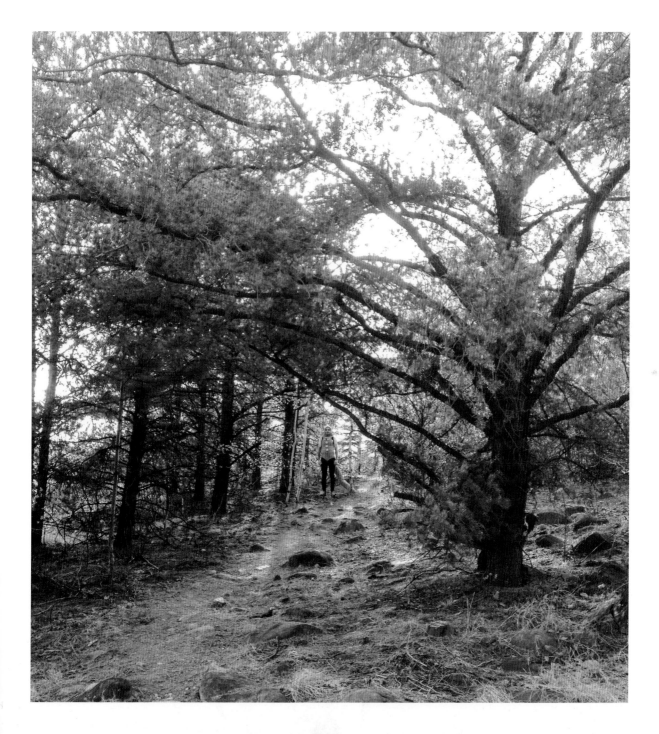

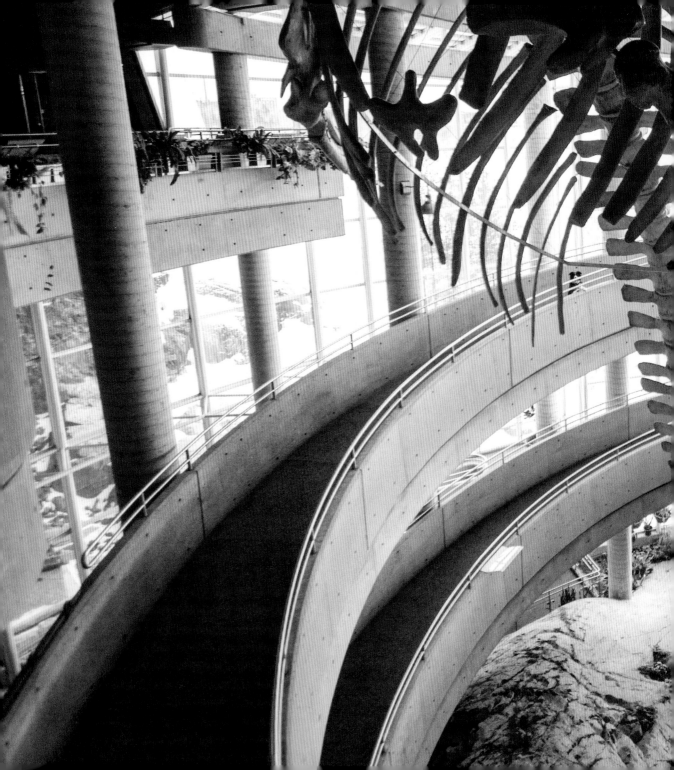

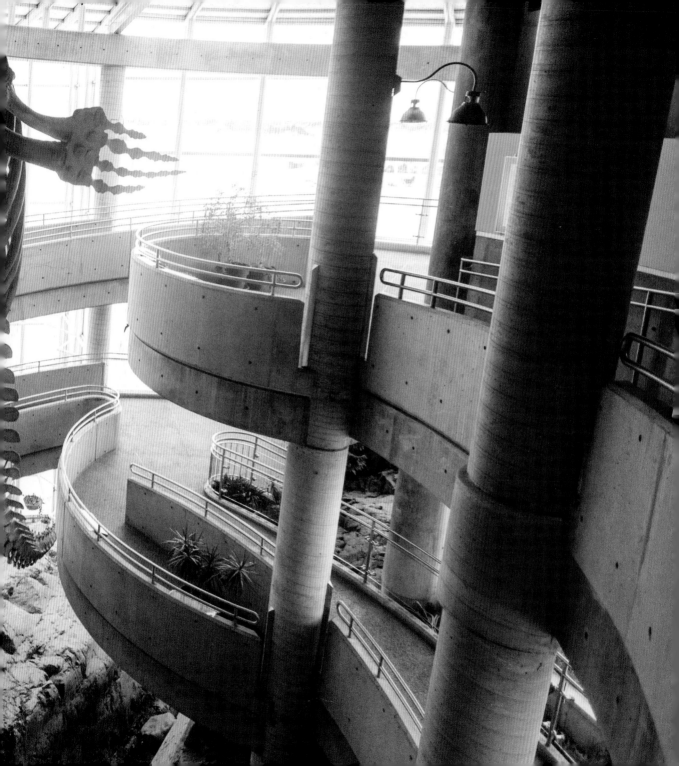

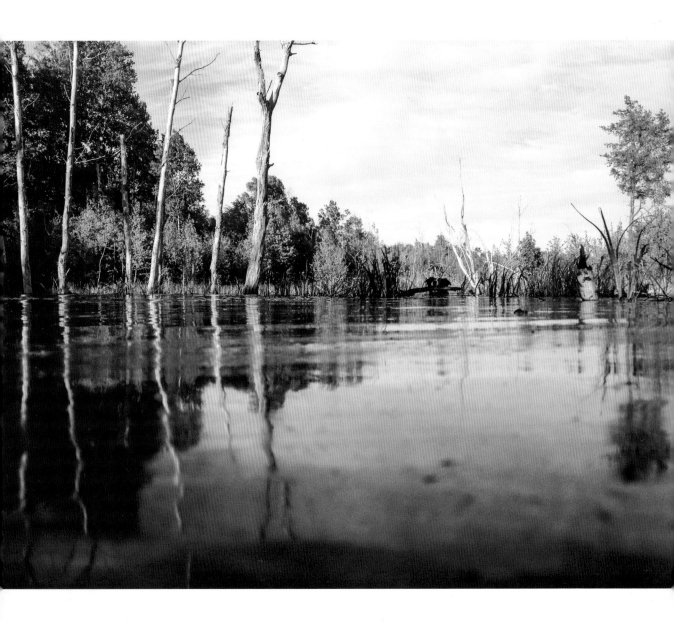

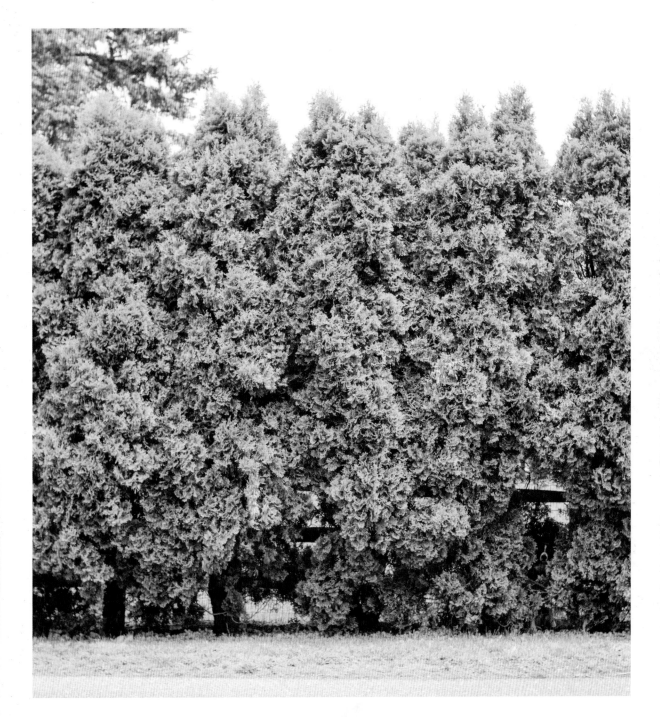

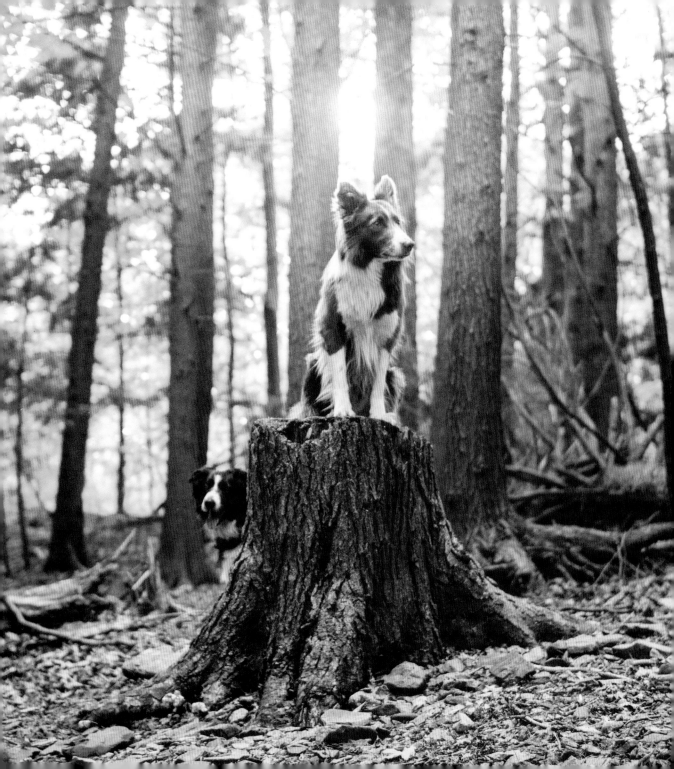

WE WERE PASSING THROUGH

Burlington, Vermont, probably the friendliest city ever, when we met Tomas and his Argentinian border collie, Pablo. Tomas recognized our van (from my Instagram feed) and shouted out "Momo!" as his car passed us on the highway. He and Pablo showed us around, fed us banana pancakes, and sent us on our way with a care package.

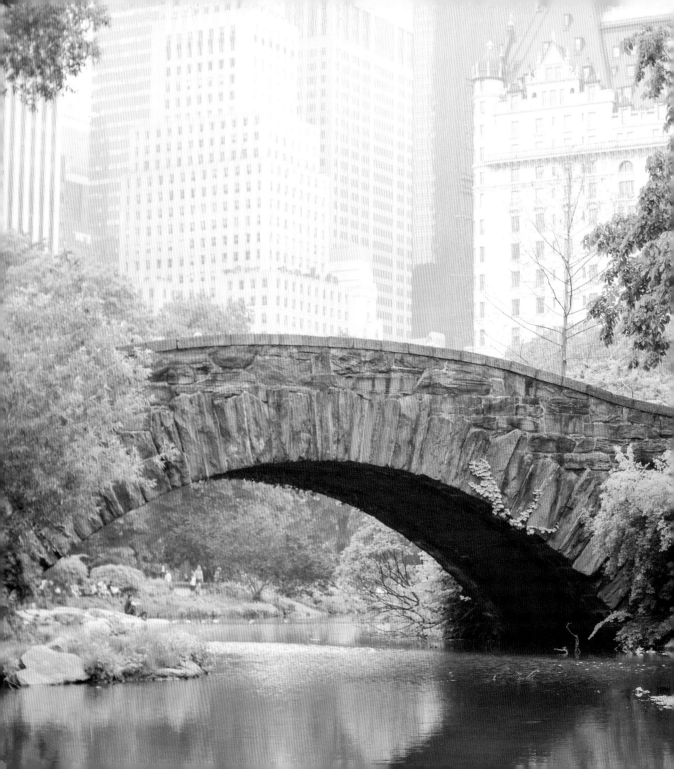

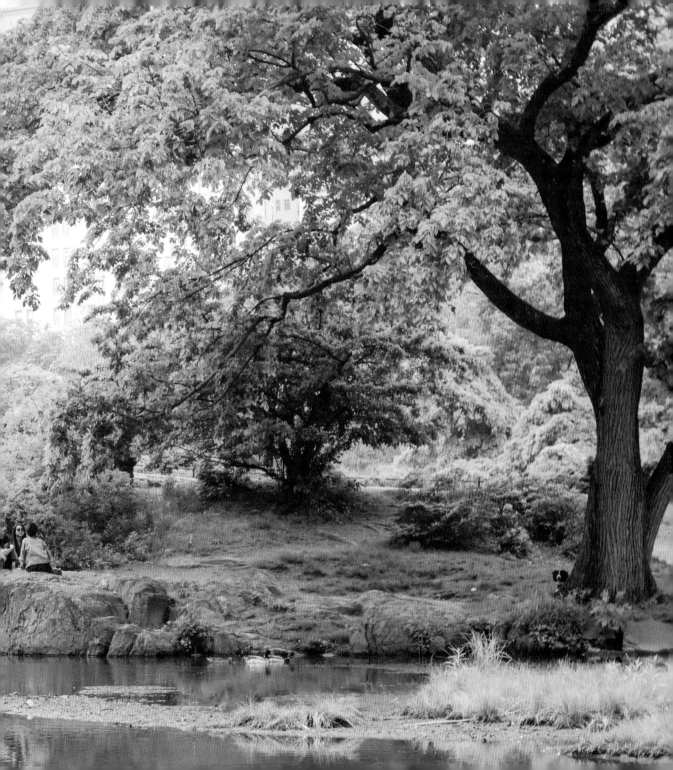

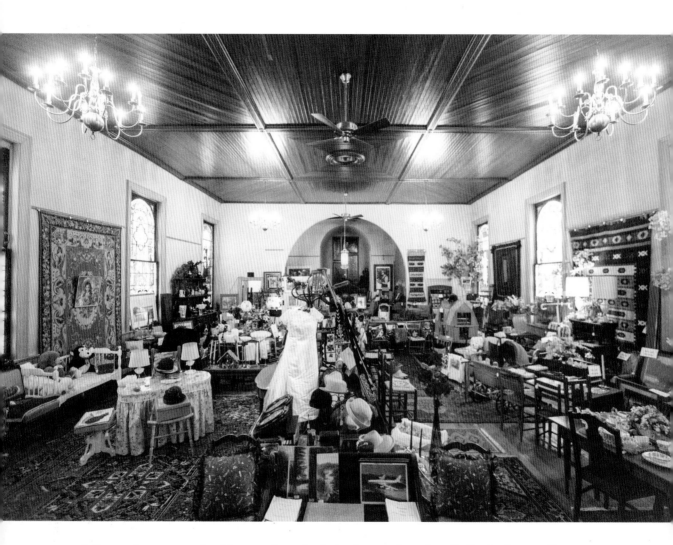

Momo is more obedient when he's indoors, but he definitely prefers being outdoors. "Go outside" is one of his favorite sentences to hear.

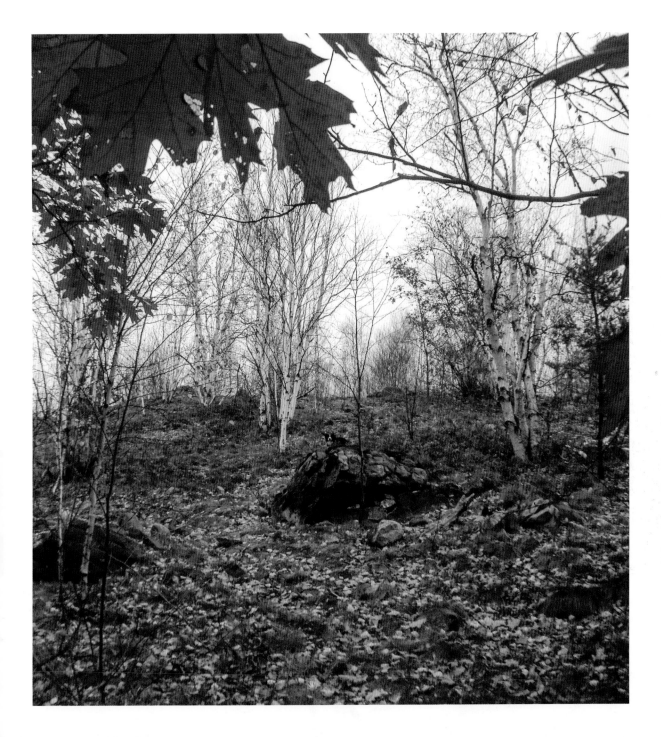

MY FRIEND ZACH

helped us with this one.
Because we weren't
really supposed to be
in this stadium, I didn't
want to yell too loudly.
So I asked Zach to stay
in the stands near Momo
and direct him while I set
up the shot. Look for one
of Zach's limbs, as well as
Momo, in the photo.

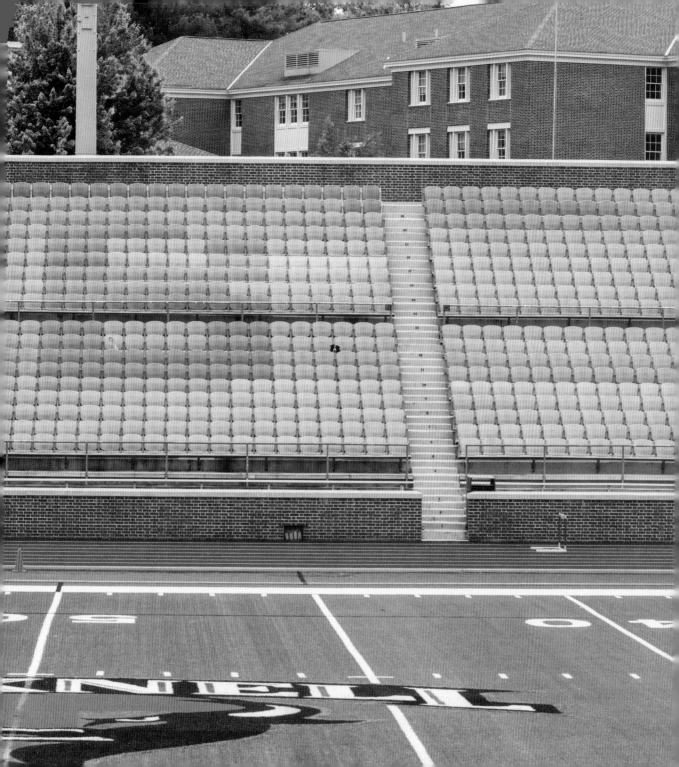

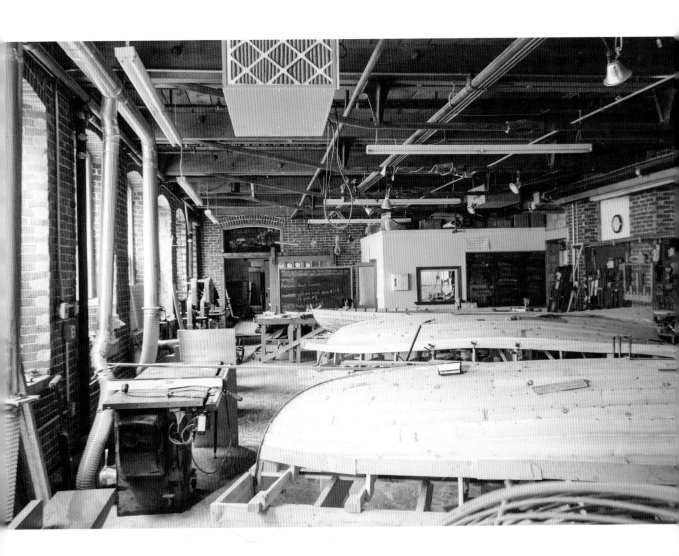

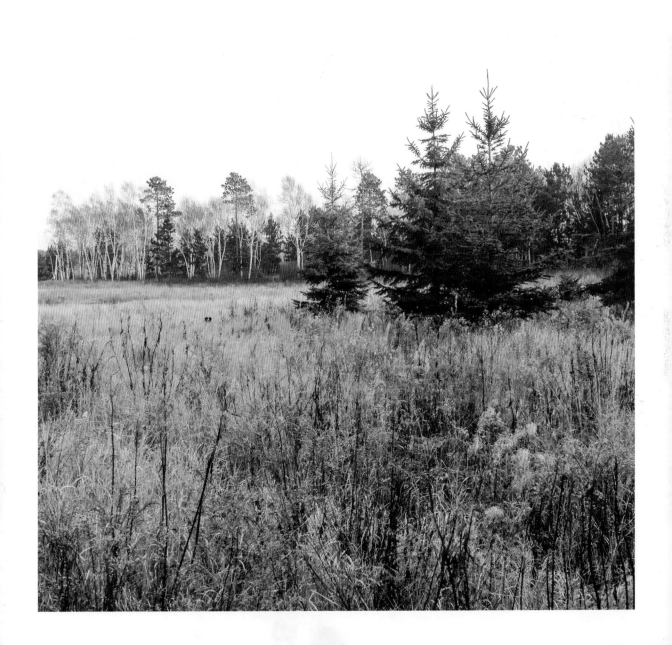

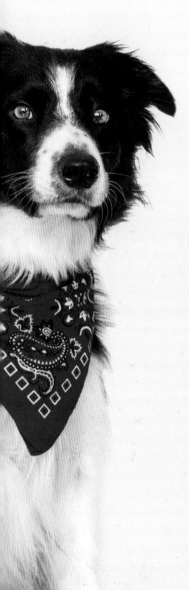

WHEN MOMO WAS A WEE PUP,
I brought him to a lake to swim for the first
time. He started paddling with his feet
before we even reached the water! He swam
as soon as he got into the lake, as if it was a
trick he'd learned in the womb.

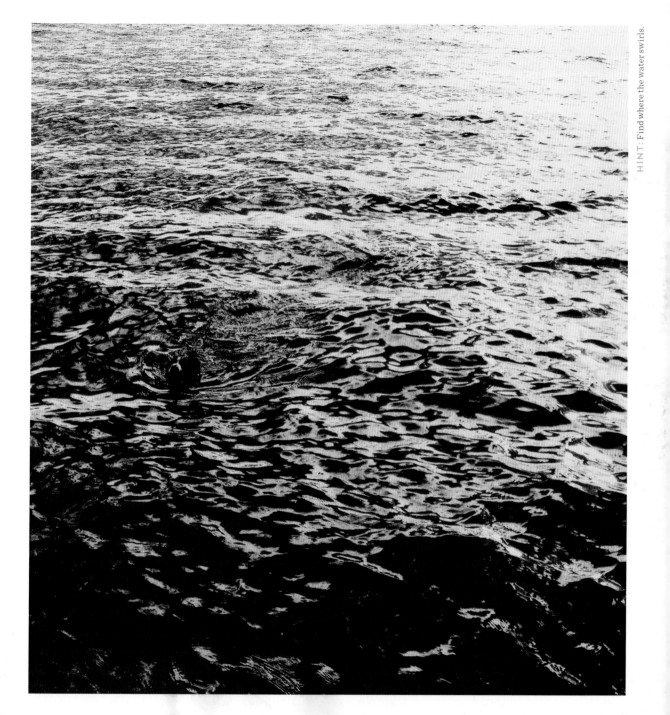

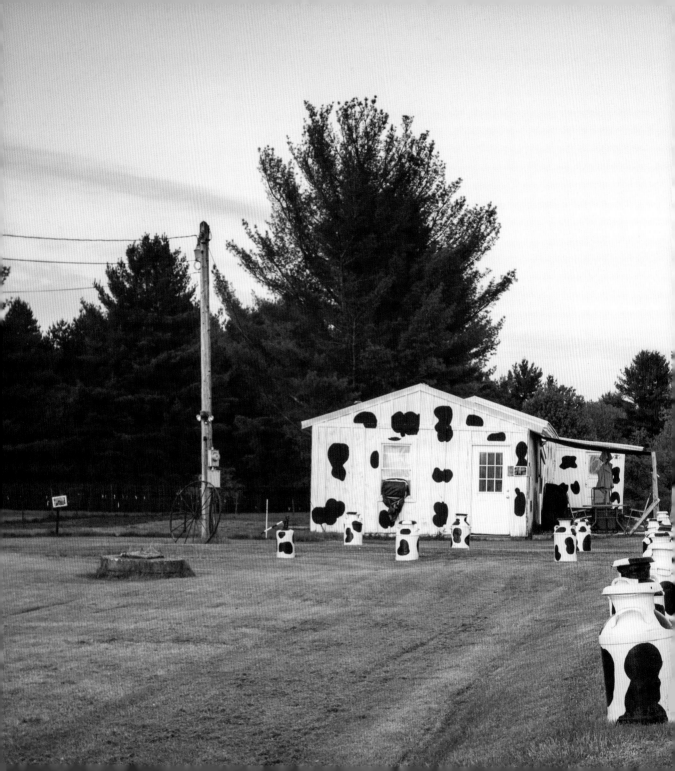

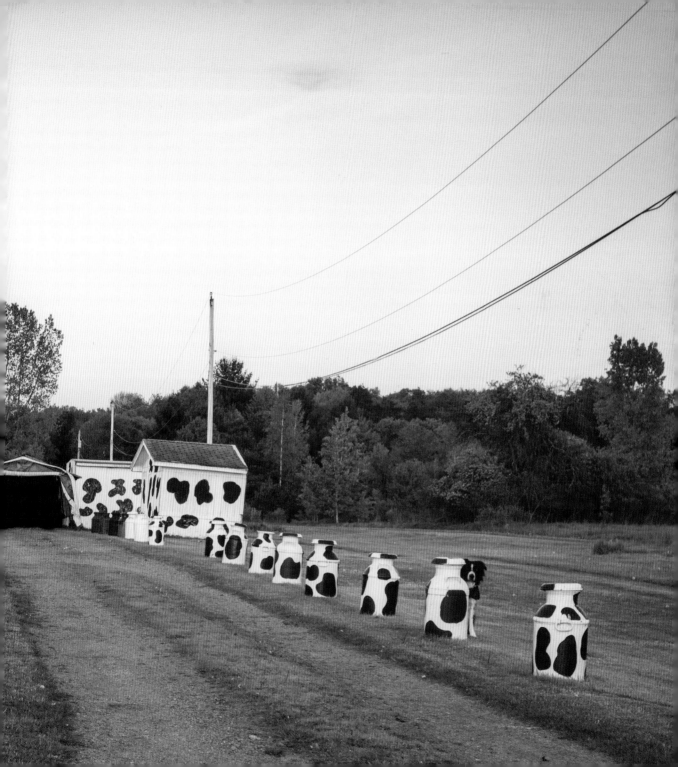

HINT: Look around the big rocks.

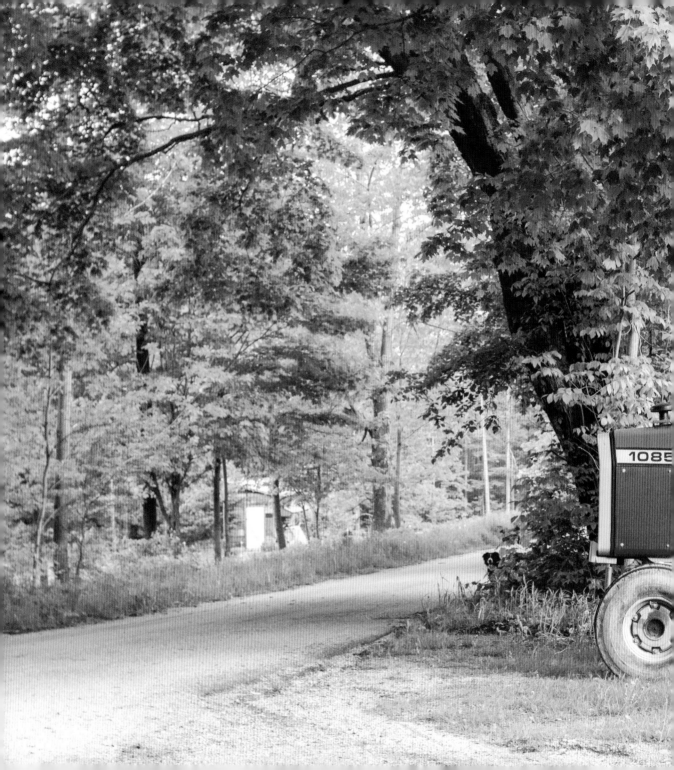

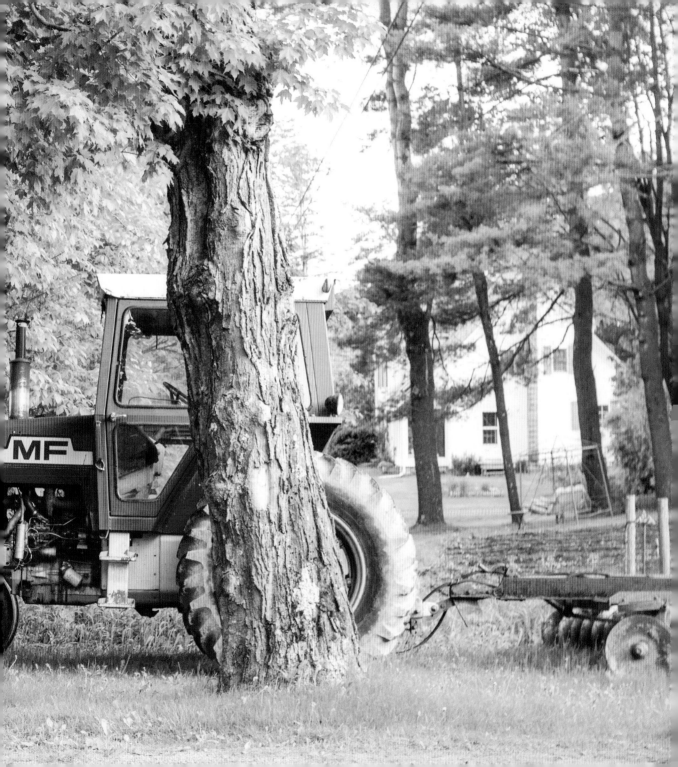

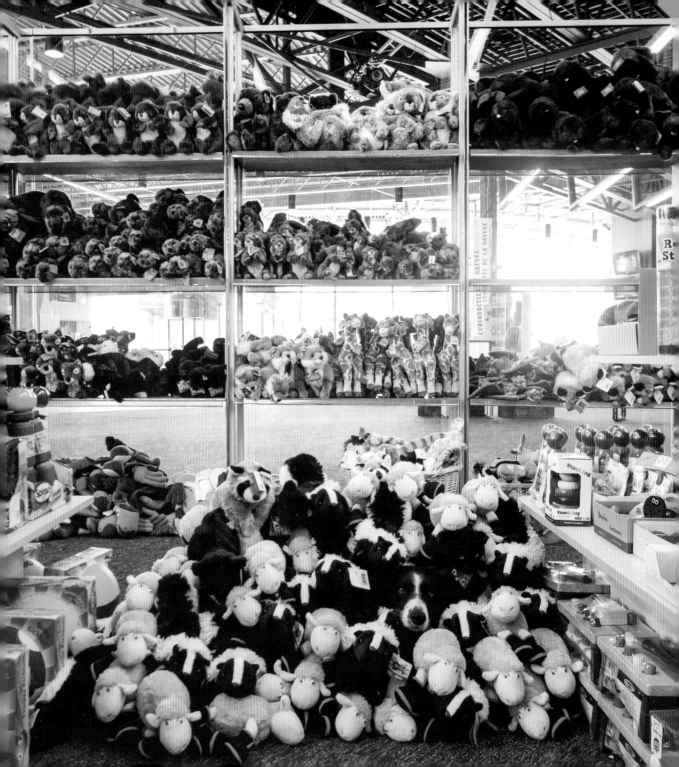

WHY DID I NAME HIM MOMO?

For no particular reason. But a few things solidified the decision:

1. Harriet, one of my dearest friends, responded enthusiastically and assertively to the idea: "You *have* to name him Momo!"

2. My uncle Morris died at age 24. We never met. But from the pictures I've seen and the stories I've heard, I know I would have loved him.

3. Soon before naming Momo, I'd gone skydiving and my tandem diver's name was Moe. You don't forget the name of the guy who makes sure your parachute opens!

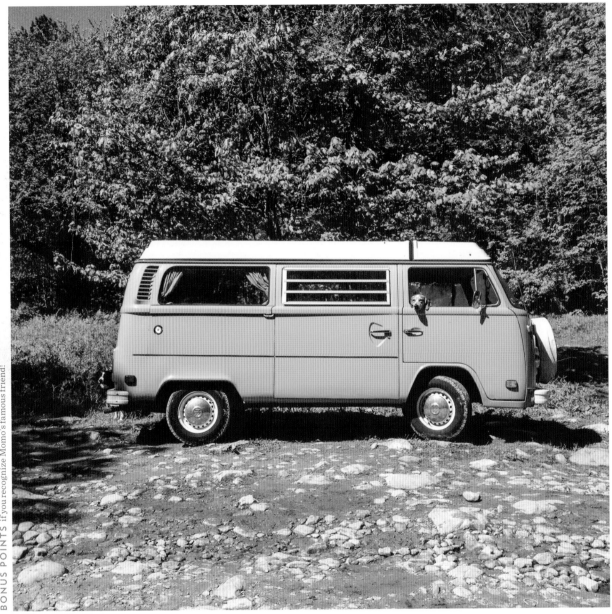

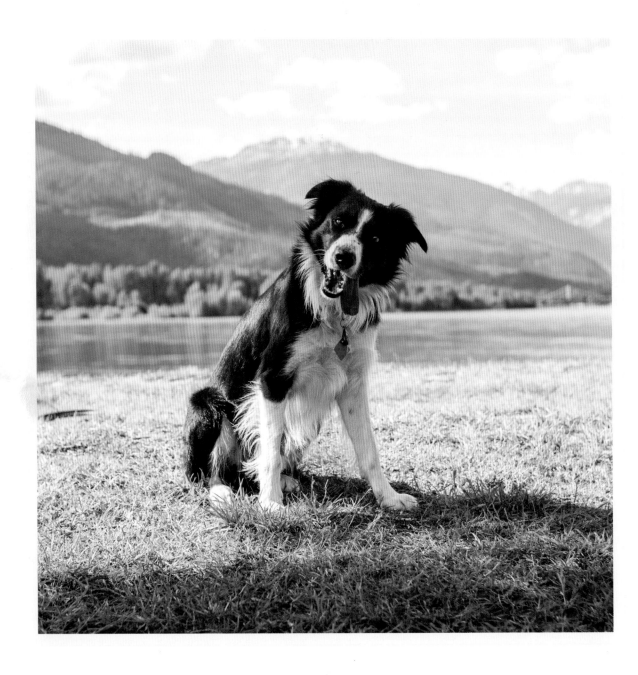

HERE'S MOMO!

Momo really travels! Read on for the low-down on where he's hiding . . . and some details about the many places he's been.

THE VAN

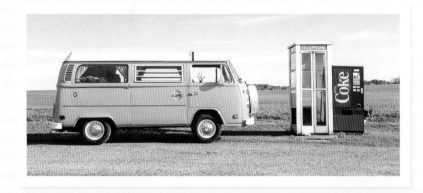

MY YELLOW 1977 Volkswagen Westfalia, also known as the "Big Yellow Van" or "Banana Van," gets recognized almost as often as Momo does. People wave, they yell, they leave notes. She's a wild stallion; she doesn't always do what I want her to, but her stubbornness is part of her personality. I absolutely love driving her, but she's so finicky that lately I find myself walking and biking more than ever. (I think that's a really good thing.) I've driven her many miles so far, and I feel blessed. An old bus like this isn't always practical, but you don't own one solely for practicality. It's a simple vehicle and I feel competent working on it (except the engine). I won't park her in bricked driveways, because she leaks a bit of oil. Anyone want to help me with the engine?

© Harriet Carlson

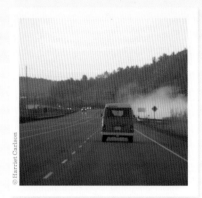

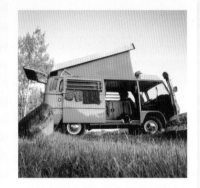

 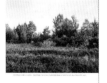

OKAY MOMO, GO HIDE!

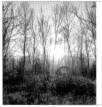 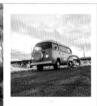

6–7
Rotary Park, Sudbury,
Ontario

8
Trail in Sudbury,
Ontario

9
Big Nickel Mine Road,
Sudbury, Ontario

10–11
Log pile near
Brandon, Vermont

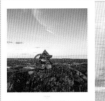
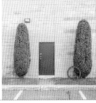
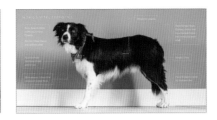
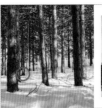
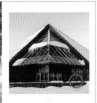

12
An *inukshuk* (stone landmark) on some mountains in Sudbury, Ontario

13
Office building in Sudbury, Ontario

16
Trail in Sudbury, Ontario

17
Fielding Memorial Park, Greater Sudbury, Ontario

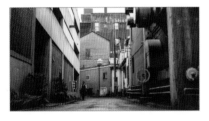

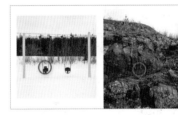

18–19
Alley in Burlington, Vermont

20
Farm near Watertown, New York

22
Playground, Sudbury, Ontario

23
Mountains in Sudbury, Ontario

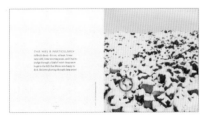
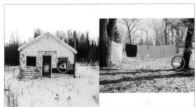
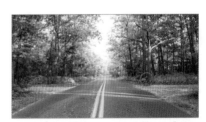

25
Rock Hill, Sudbury, Ontario

26
House near French River, Ontario

27
Toronto Islands, Ontario

28–29
Lebanon State Forest, New Jersey

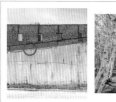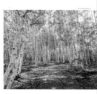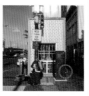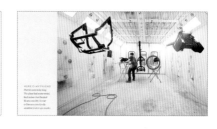

30
Sudbury, Ontario

31
Fielding Memorial Park, Sudbury, Ontario

32
Somewhere in the Ottawa Valley, Ontario

33
Market Street, Philadelphia, Pennsylvania

34–35
Beau Precision, auto body shop in Sudbury, Ontario

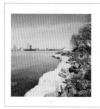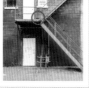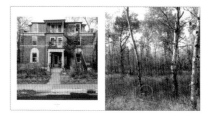

36
Toronto Islands, Ontario

37
Blue building, Downtown Sudbury, Ontario

38–39
Toronto Fire Station #426, Toronto, Ontario

40
Cedar Street House, Sudbury, Ontario

41
Lake Laurentian Conservation Area, Sudbury, Ontario

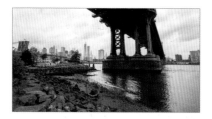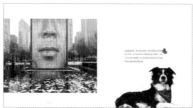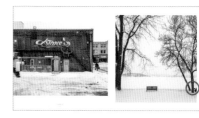

42–43
Dumbo Park, Brooklyn, New York

44
Millennium Park, Chicago, Illinois

46
Lot behind Speakeasy tavern, Sudbury, Ontario

47
Bell Park, Sudbury, Ontario

CLUTTERED PORCH

I HAD HEARD about this unique house in Toronto, and one day, while gallivanting with my friends Zach Rose and Jacklyn Barber, I finally went to see it. Before photographing someone's house, I like to ask permission, so I knocked on the front door. There was no response, so I happily gave up and turned to leave. Just then, I heard the door swing open. A kind little man came out. He told us we could do whatever we wanted, as long as we left him a photo in the mailbox. The whole place felt kind of otherworldly: a yard filled with toys, you don't see that very often. But I quite admired it. It takes a lot of nerve to do something you're certain people will notice. And when you make a statement—even if it doesn't mean

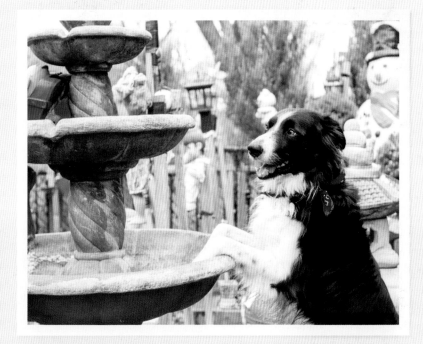

anything to anybody but you—you give other people permission to make an equally loud statement in response. Whether the owner of this house intended to or not, he was inspiring people. At the very least, he inspired me to share this photo with you.

48–49
Dumbo Park,
Brooklyn, New York

50
Bell Park, Sudbury,
Ontario

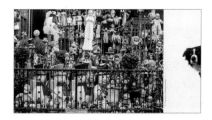

52–53
Porch in Toronto,
Ontario

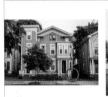
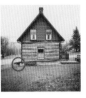
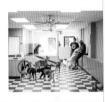
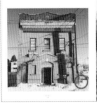
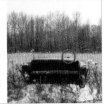

54
House on Orange Street,
New Haven,
Connecticut

55
House in Cobden,
Ontario

57
Dog School, South
Street, Philadelphia,
Pennsylvania

58
Sault Ste. Marie,
Ontario

59
Sudbury, Ontario

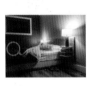
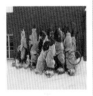
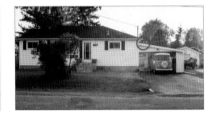

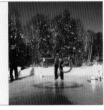

60
Momo and Andrew's
bedroom, Sudbury,
Ontario

61
Behind an abandoned
school in Sudbury,
Ontario

62–63
Home in Sudbury,
Ontario

65
Wolfe Lake, Greater
Sudbury, Ontario

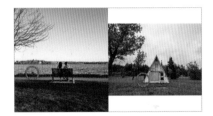

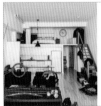
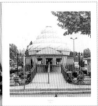

66
Bell Park, Sudbury,
Ontario

67
Triangle House,
Highway 17, between
Sudbury and Verner,
Ontario

68
Loft in Kensington
Market, Toronto

69
Twistee Treat,
Wernersville,
Pennsylvania

70–71
Field in Ashfield,
Massachusetts

BASS PRO SHOP

WHEN THE HEATER in my van broke during an attempted cross-country trip, I stopped at this Bass Pro Shop in Peoria, Illinois. The moment I saw the giant aquarium and diorama (and moose), I knew I had found my shot. I told Momo to sit and stay, and as usual he didn't budge, even though a ton of people were watching us. When we finished, I heard a few claps and a bunch of wows. I guess the customers enjoyed the impromptu performance. I bought a new heater. Momo stayed under a blanket when it got too cold. I had numb fingers for the rest of the trip.

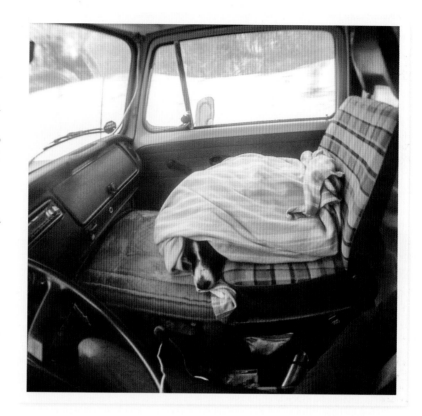

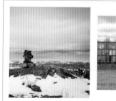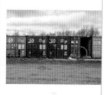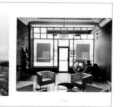

72
An *inukshuk* (stone landmark) on mountains in Sudbury, Ontario

73
Storage Containers in Sudbury, Ontario

74
Mountains near Sudbury, Ontario

75
Fuel Multimedia, Downtown Sudbury, Ontario

77
Bass Pro Shop, East Peoria, Illinois

Behind the Scenes

WOODPILE

THIS PHOTO WAS taken on Route 17C outside Endicott, New York, during a weeks-long photography road trip. To get Momo positioned where I wanted him, my friend Zach offered to hide behind the woodpile with Momo sitting on his back! Momo was fine with it. We befriended the lumberjack selling the wood, though we fumbled our words a bit trying to explain what we were doing. Afterward, we bought the bundle of wood that Momo had been hiding behind (the guy even gave us a few extra logs). We later burned the wood in a campfire with some new friends we made on the back roads of Pennsylvania.

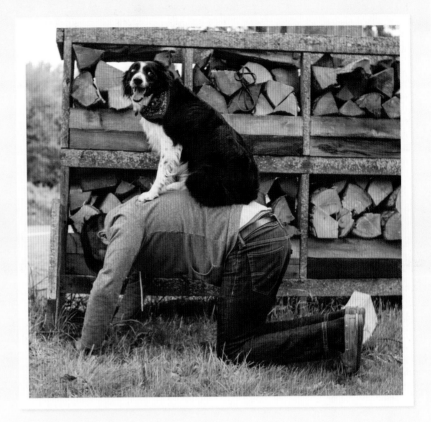

78–79
Toronto Islands,
Ontario

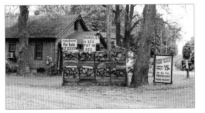

80–81
State Route 17C,
outside Endicott,
New York

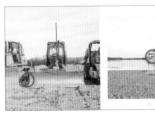

82
Rotary Park, Sudbury,
Ontario

83
Moonlight Beach,
Minnow Lake, Ontario

Find Momo
• 134 •

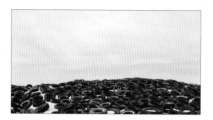

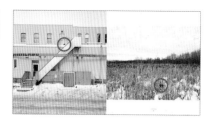

84–85
Tire pile near
Burlington, Vermont

86
Roy's Furniture,
Downtown Sudbury,
Ontario

88
Downtown Sudbury,
Ontario

89
Field near Sudbury,
Ontario, Ontario

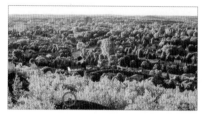

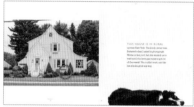

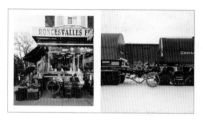

90–91
New Sudbury,
neighborhood in
Sudbury, Ontario

92
House near Endicott,
New York

94
Roncesvalles,
neighborhood in
Toronto, Ontario

95
Train near a Rainbow
Routes trail in
Sudbury, Ontario

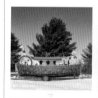

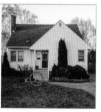

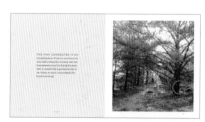

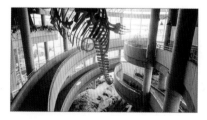

96
Noah's Ark at Logos
Land Resort, Ottawa
Valley, Cobden, Ontario

97
Sudbury, Ontario

99
Trail in Sudbury,
Ontario

100–101
Science North, a science
education center in
Sudbury, Ontario

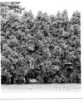
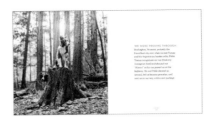
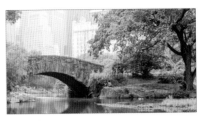

102
Laurentian
Conservation Area,
Sudbury, Ontario

103
Behind Twistee Treat,
Wernersville,
Pennsylvania

104
With Pablo in
Burlington, Vermont

106–107
Central Park,
New York, New York

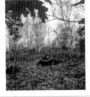
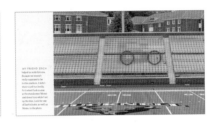
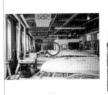

108
The Antique Pew,
Pittsford, Vermont

109
Forest near Moonlight
Beach, Minnow Lake,
Ontario

110–111
Bucknell University,
Lewisburg,
Pennsylvania

112
Philadelphia Wooden
Boat Factory,
Philadelphia,
Pennsylvania

113
Laurentian
Conservation Area,
Sudbury, Ontario

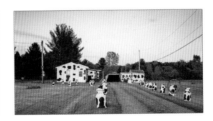

115
Moonlight Beach,
Minnow Lake, Ontario

116–117
House near Parish,
New York

118
Mountains near
Sudbury, Ontario

119
Woods near Sudbury,
Ontario

Behind the Scenes

MOMO & MADDIE

WHEN I WAS traveling around New England with Zach and Momo, we ran into photographer Theron Humphrey and his lovely coonhound Maddie (featured in Theron's book *Maddie on Things*). Theron and photographer Garrett Cornelison were on tour to promote the book and to spread the word about rescue dogs via WhyWeRescue.com. I've been a longtime fan of Theron's work. Even though I ran over his projector screen with my van, he and Garrett kindly shared some words about travel, success, and connection that I won't soon forget. As for Maddie and Momo—as you can see, they connected just fine.

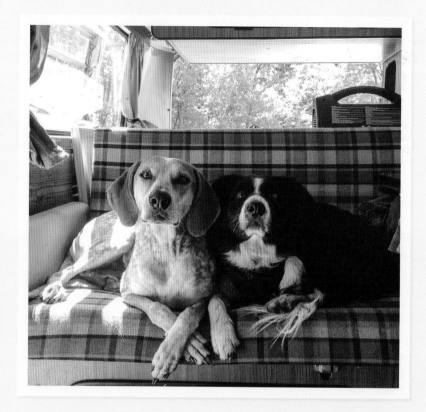

120–121
Green Mountain
National Forest,
Vermont

122
Gift shop at Science
North, a science
education center in
Sudbury, Ontario

124
With Maddie in Green
Mountain National
Forest, Vermont

125
Field in Sudbury,
Ontario

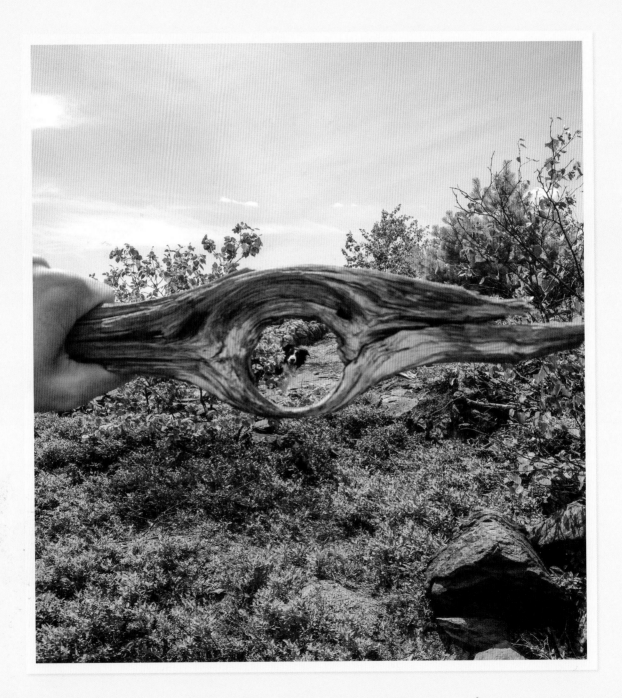

MOMO AND ME AND YOU AND EVERYONE

ONE AUTUMN DAY in 2012, I brought my border collie Momo to one of our favorite spots in the woods near my house. We have lots of forests in northern Ontario; some are filled with trees no taller than five or six feet, thanks to recent regreening efforts in areas that were once barren (the result of pollution from nickel smelting). I picked up a stick to throw, and Momo ran off to where he expected it to land (it's what he always does; I think it's a border collie thing). After a little searching, I saw Momo partly hidden behind one of the little trees, waiting. And I thought, "This is a nice scene. I'm not going to throw this stick. I'm going to ask him to stay, take a picture, and *then* throw the stick."

Soon after taking what would become the first of many hide-and-seek shots, I created the #findmomo hashtag and began sharing Momo's pictures with my 600 or so Instagram friends. Before long, Momo's Instagram feed had more followers than I could have imagined; in a matter of weeks our audience grew to more than 50,000 people. Blogs and news outlets began spreading the word. Watching the photos go viral was fascinating. The world really seemed to respond to this project. Maybe it's the photography, or maybe it's the game of hide-and-seek. I would hope it's a mix of the two.

Momo hides instinctively; I don't know what his intention is. If I'm throwing sticks in the forest, he runs off and waits, and more often than not he's somewhere I can't see him. But he can see me. Occasionally, it's Momo who chooses the location for his photo sessions. The rest of the time, I'll see a beautiful scene, or a nice sunset, or a giant brick wall with a hole in it. I'll bring Momo there and ask him to "stay." And he will, for 10 minutes if I ask him to (though it normally takes no time at all).

Momo's a working dog by nature, and his work ethic is incredible. He'll go where we need to go and wait patiently while I compose the shot. From a distance, I can signal him to sit up or lay down. Once I told him "Back up," and he did . . . and then I realized I'd never taught him that command. He'd learned it on his own, because I'd said those words so many times while guiding him backward!

I've learned a lot, too, maybe even as much as Momo has. When I was growing up, the idea of going into the woods terrified me. But giving this dog a happy and full life meant walking the forest trails and then, when that got boring, venturing deeper where there were no trails. On those walks I felt like I'd stumbled across an undiscovered world. Thanks to Momo, the place that once completely freaked me out has become the place I go to clear my head.

Sometimes technology seems to split people apart, or send each of us into our own separate little worlds. (I'm as guilty of that as anyone. I'm getting better, though friends still chide me for constantly checking my phone during dinner.) But through technology, art can pull us in, bring us together, give us something to relate to and talk about. One of the best aspects of this project has been witnessing how technology enables people to come together, with the help of Momo's pictures. When I hear about a mother who just spent a couple of hours looking at my photos online with her daughter, or a boy who asks his father every morning to look for Momo, that's when I feel like Momo and I have really done our job.

When I first met Momo, I had no doubts we'd be good buddies. Life is better with a dog. Dogs take care of us. They help us meet new people. This is one of my favorite things about the Find Momo project: the potential for connection that it creates. I hope you enjoy meeting Momo, and if you don't have a dog in your life, don't worry. Dog owners are usually pretty social. Just ask one "Can I pet your dog?" Strike up a conversation, and make a new friend.

Then invite your new friend to Find Momo.

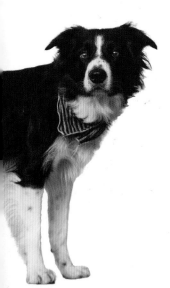

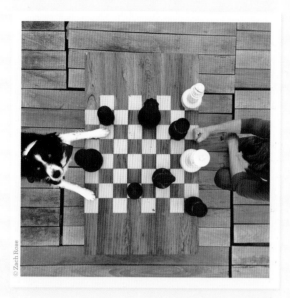

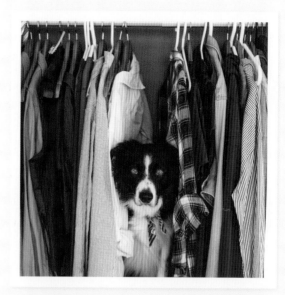

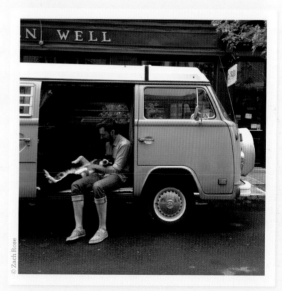

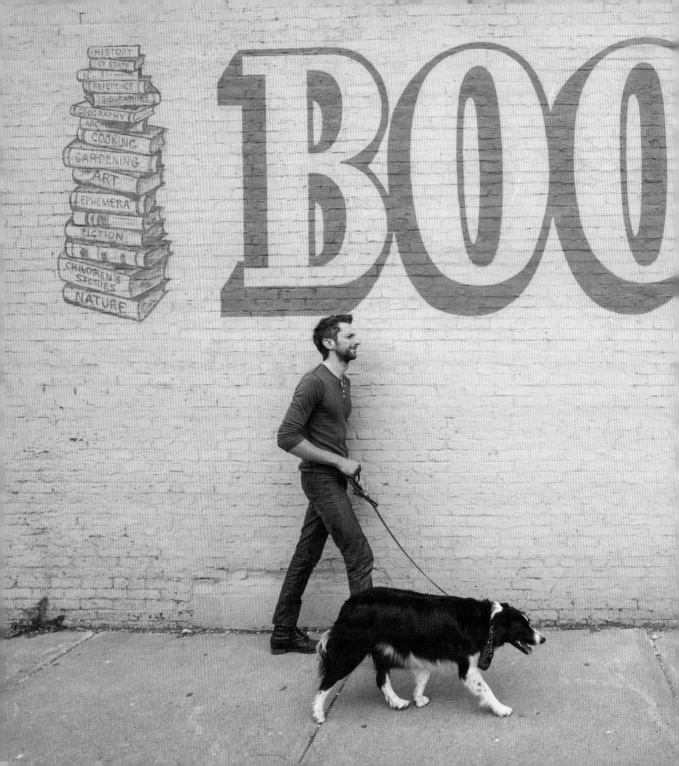

THANKS

to my friends and family for their support, and to the strangers I've met along the way who are now friends.

For making this book a reality, a really big thanks and unlimited belly rubs for the folks at Quirk Books, namely Margaret, Andie, Rick, and Katie for the countless hours spent putting the puzzle together and making sense of my thoughts, and to Nicole, Eric, and the rest of the team for spreading the word. I owe much gratitude to my new friends at Random House, and all the good folks at Random House of Canada.

To Zach for being an unexpected character in the book, and for all the help on the road. To Mike, Ash, Rob, Virginia, Adam, Jen, Christian, Kyle, Harriet, Danielle, Matt, Amber, Nova, Faye, Jackpot, Jeff, David, Yoshi, Tomas, Pablo, Razor, Shep, Molly, Wynnie, Maddie, the Framptons, Lasalle Animal Clinic, the Sudbury downtown crew, Auntie Carrie, and anyone who's ever dog-sat, lent me an ear, given advice, or offered a hug.

MORE MOMO!

You can always find Momo online
at QuirkBooks.com/FindMomo
and Instagram @andrewknapp

- Find out what Momo's up to
 and where he's been lately

- See all-new Find Momo images

- Download Momo wallpapers

- And much more Momo!